Mosaics

IN A WEEKEND

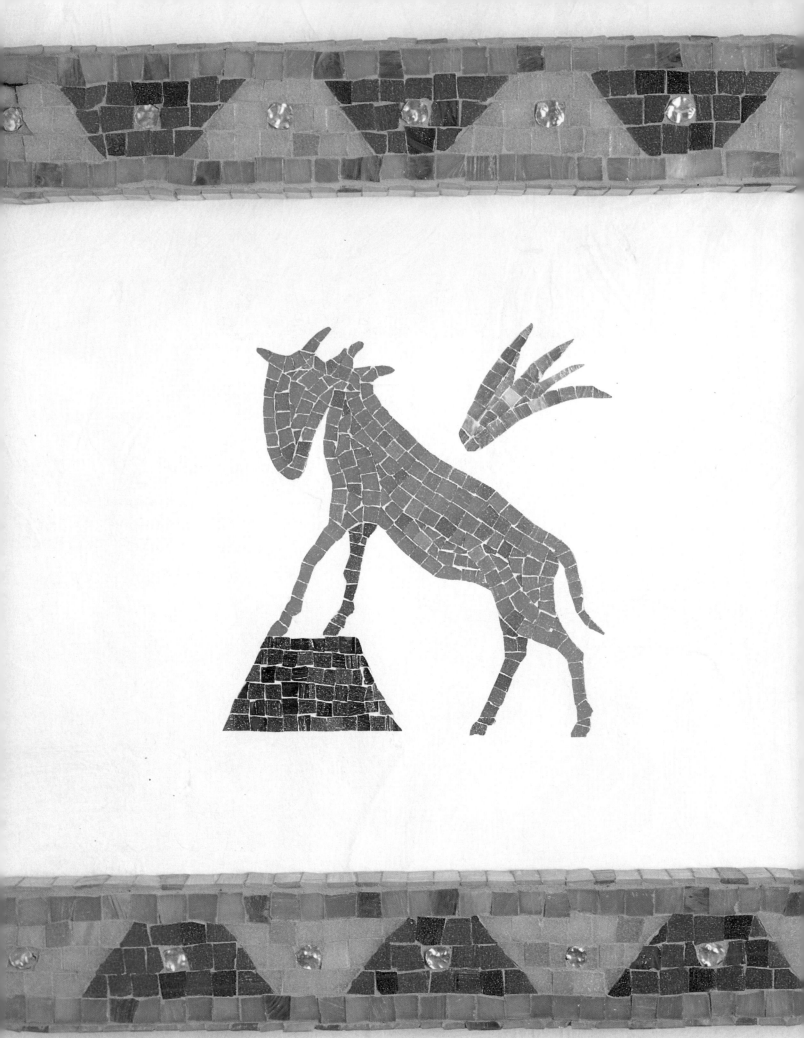

Mosaics

IN A WEEKEND

Inspirational ideas and
practical projects

M A R T I N C H E E K

NEW HOLLAND

To my dear wife Margaret, who has stayed
with me and supported me through thick
and thin, and given birth to dear Thomas
and Mollie, my *raisons d'être.*

First published in 1997 by
New Holland (Publishers) Ltd
London · Cape Town · Sydney · Singapore

Reprinted in 1997 (twice)

24 Nutford Place
London W1H 6DQ
United Kingdom

80 McKenzie Street
Cape Town 8001
South Africa

3/2 Aquatic Drive
Frenchs Forest, NSW 2086
Australia

ISBN 1 85368 926 2 (hb)
ISBN 1 85368 927 0 (pb)

Editor: Emma Callery
Designer: Peter Crump
Photographer: Shona Wood

Editorial Direction: Yvonne McFarlane

Reproduction by Hirt and Carter (Pty) Ltd
Printed and bound by Times Offset (M) Sdn. Bhd.

Important:
Every effort has been made to present clear and accurate
instructions. The author and publishers can accept no
liability for any injury, illness or damage which may
inadvertently be caused to the user while following them.

CONTENTS

INTRODUCTION

Surprisingly, the word 'mosaic' has no literal translation. Some scholars have suggested that it means 'crazy', which even if not absolutely accurate, seems to be entirely appropriate at times.

Mosaic is certainly enjoying something of a renaissance at the moment. I have been running three-day mosaic courses for many years now and their popularity has grown as the public have slowly realized that they, too, can make beautiful mosaics for themselves. It never fails to amaze me that what appears at first glance to be such an inflexible material, can produce results that are so stylistically different and individual.

The Italian master mosaicists had to train for many years before being allowed to tackle big public works. Understandably, they were (and still are) very secretive about their techniques. What they would think of a three-day mosaic course (or this book, which for some projects works on the principle that just completing the mosaicing can take a 'long weekend' – three days) is not worth repeating. But the fact remains that wonderful things can be, and are, achieved in this short space of time. So let's let the mosaics speak for themselves.

ABOUT THE PROJECTS IN THIS BOOK

The projects have been chosen to show the wide range of styles, materials and techniques available to the modern mosaicist. Choose the ones that suit your temperament – it is unlikely that someone who feels drawn to the Gaudiesque style of using great big chunks of broken pottery is also going to enjoy the painstaking work involved in nibbling fine detail for an intricate design.

I strongly recommend that you read the chosen project through carefully before you start. There is nothing more maddening than to have to stop work because you have forgotten a vital piece of equipment. You will also notice that there are times when you will need to wait, say, for glue to dry. It is important to realize this before you begin a project, so that you don't get disappointed when you find you have to wait, for example, a whole week for cement to set.

I have tried to choose projects that range from simple ones that can be achieved in a morning (for example, the Trivet on pages 26-7 and the Shell Door Number on pages 34-5), although the grouting will have to be left to set for the next two to three days. Others are more advanced (for example, the Roman Paving Slab on pages 52-5), and it may take up to three days to complete the mosaic work and then there will be additional waiting time while the concrete sets. There are plenty of mosaics for internal and external settings. Mosaic has the added advantage of being able to be wiped clean, so you can hang it in your kitchen or bathroom. Other projects have been chosen simply because they make perfect gifts.

MATERIALS AND QUANTITIES

The tile quantities listed at the beginning of each project are meant as a guide only, and in the lists of quantities required, I have always allowed an additional 25 per cent for wastage. If you don't have, or have run out of, a certain colour, feel free to substitute a different one of your own choice – if you choose a colour that has the same tone (imagine it in a black and white reproduction – is your choice tonally similar?), then the tonal range of the piece, and more importantly, the contrast between the subject and background, will remain.

You won't be able to buy the mosaic tiles in the small quantities listed in each project, so please don't try. Instead, I suggest that you buy a 25-kg (50 lb) box of vitreous mix, which is basically scrap, but it is soon sorted into jars. This also has the benefit of containing some colours that are not available in the standard range and you can make up any particular colour you need separately once you know what you have got.

You may also find, when buying specific colours, that they can vary in shade from batch to batch. Because of this, if you want consistency in a certain colour, make sure that you buy a sufficient quantity before you start. I actually like the fact that the mixed box gives you subtle differences of the same colour and for this reason always keep a box or two handy in my mosaic studio. You will find that in the mixed boxes you get a predominance of blues, greens and whites. This is because 95 per cent of all 'vitmos' is bought for cladding swimming pools – and who wants a flaming red swimming pool?

Your mosaic room will soon resemble a sweet shop with jars full of beautifully coloured tiles inspiring you to get started – so off you go!

Martin Cheek

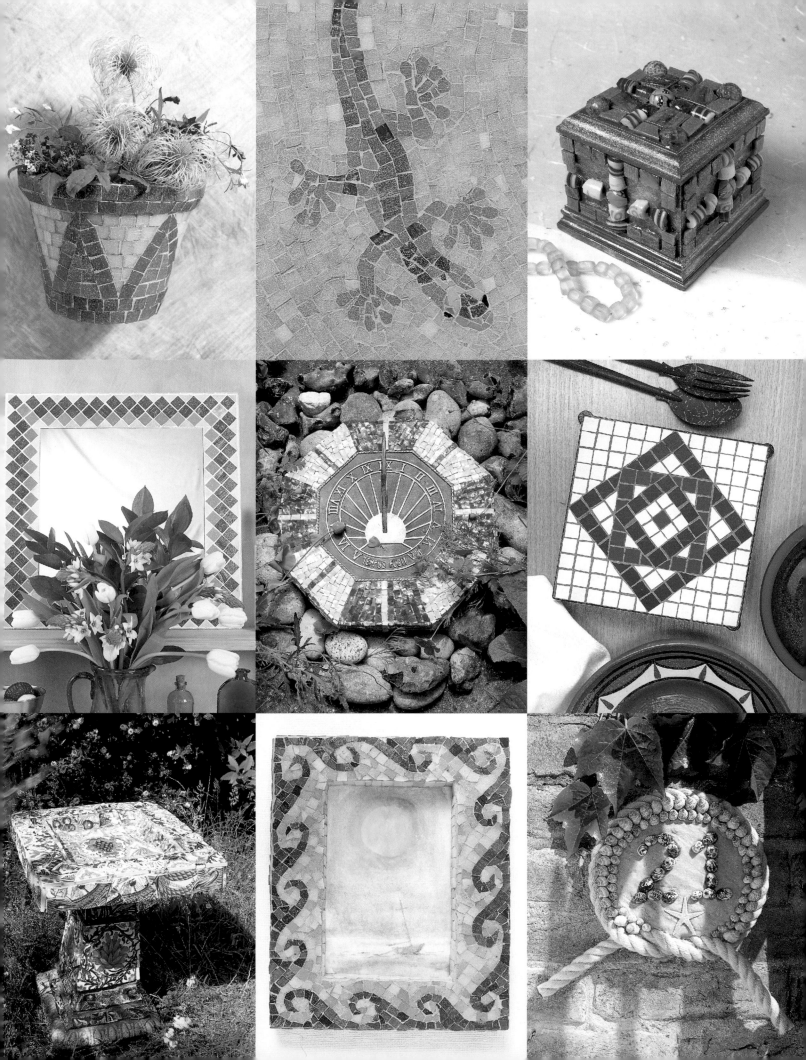

GETTING STARTED

The list of tools, equipment and materials, given at the beginning of each project certainly looks daunting, but you will soon realize that apart from the mosaic tiles, many of the tools are standard and can be used around the house for other jobs. You are likely to have many of them already.

EQUIPMENT AND MATERIALS

MOSAIC TILE NIPPERS

The first thing that you will notice about the mosaic nippers, compared with, say, a pair of scissors, is that the pivot point is extremely high. The handles curve in towards the bottom and this is where you are meant to hold them. The combination of these two factors gives the nippers maximum leverage so that you do not have to work hard when you are cutting the tiles. The handles are sprung so that you do not have to pull them apart each time you cut a tile. The jaws of the nippers are made of tungsten carbide for strength. They don't meet up when you close them, this is correct.

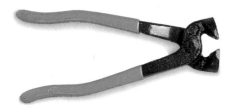

Also in contrast to a pair of scissors, they cut at right angles to the handles. One side juts out and this is the side that you use to cut the tiles in straight lines. If you practice at using the jaws the 'wrong' way round you will soon learn how to cut curved lines.

TWEEZERS, TONGS AND DENTAL TOOLS

From time to time you may find it helpful to use a pair of tweezers to finely 'tweak' the tesserae. Some people prefer a simple cocktail stick.

Miniature tongs can also be obtained. At first these might be mistaken for tweezers, but in fact the prongs open, not close when you squeeze your fingers. A pair of these are excellent for picking up small fiddly tesserae, too small for your fingers. (Or too close to your recently completed area to risk picking up with the naked hand.)

Dentist's tools can be bought from surgical or sculptural suppliers and are excellent for 'poking' and 'prodding'. Being made of metal, you can remove the glue with a scalpel once it has dried. They are expensive though, so try asking your dentist if he has any old ones he no longer needs, you may be lucky.

BUILDER'S FLOAT

A builder's float is a square piece of wood about 30 x 30 cm (12 x 12 in). It has a handle on one side and is used to smooth or flatten sand, cement or concrete.

LEVELLING TOOL

A levelling tool is needed to flatten out the surface of a sand bed prior to making an indirect pebble mosaic (see page 48). You can make a levelling tool quite easily. For example, for the Pebble Mosaic, which measures 66 x 48 cm (26 x 19 in), cut two lengths of 10 x 2.5 cm (4 x 1 in) batten. Cut one to 48 cm (19 in) and the second to 74 cm (29 in). Then glue and nail them together with 13 cm (5 in) sticking out at either end. This levelling tool sits on the adjacent sides of the mould, and by running the tool across the top of the mould you can level out the sand.

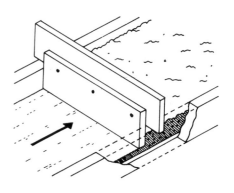

GLUES

• **PVA (POLYVINYL ACETATE)** is the standard glue used for gluing down the tesserae when making a direct mosaic. Although you can buy 'waterproof' PVA (EVA), it is still not recommended that you put a direct mosaic made using PVA out of doors. In winter, moisture can seep in through the grout and freeze into frost. As it freezes, it will expand and force the tesserae off the board.

For indoor use, though, PVA is perfect and has the added advantage of being very user-friendly – no harmful smells and it washes off your hands easily with soap and water. When wet it is white, but as it sets it turns clear. Once set, the bond is actually very strong, as anyone who has tried to correct mistakes by ripping up glued-down tesserae can testify.

• **WALLPAPER PASTE AND WATER-SOLUBLE GUM.** The basic principle of indirect mosaic is to glue the tesserae, flat side down, to craft paper, cement it to your rendered wall or floor and then soak off the paper with warm water.

Thus the glue required needs to be water-soluble. I find wallpaper paste ideal for this. It is cheap, it lasts a long time and you can mix it to the consistency that you like. Children's paper paste that comes in little pots with a rubber nozzle dispenser is also fine. Basically, any water-soluble glue will do the job.

• EPOXY RESIN. For outdoor purposes and when occasionally a stronger glue than PVA is required, two-part epoxy resin is the answer. It is available from ironmongers and department stores and comes in 'tube' or 'syringe' form. I recommend the syringe type as this ensures equal dispensing of the two parts. In a well-ventilated room, mix the two parts together thoroughly with a metal modelling tool or lollipop stick. It is advisable to use a metal modelling tool to do this as it is stronger and more controllable and you have the advantage of being able to clean it with the scalpel once the glue has hardened. If you use a lollipop stick, you will need to change it from time to time. The quick-setting epoxy resin has a 'working time' of about five minutes and a 'setting time' of about 15 minutes. The slow-setting epoxy resin has a 'working time' of about an hour and a 'setting time' of about 16 hours.

MOSAIC MATERIALS

• VITREOUS GLASS. 'Vitreous' simply means non-porous. This is the material which is used to line swimming pools and is therefore familiar to all of us. The colour range is good, the standard range consists of 50 colours and extra ones become available from time to time. (Snap these up whenever you see them!) Naturally, because the majority of the market for these tiles is swimming pools there is a much better choice of blues, greens and whites than of any other colour.

Vitreous glass tiles come mounted on paper in sheets of 15 x 15 tiles, each square measuring 2 x 2 cm (¾ x ¾ in). Each coloured sheet has a 'series number' rather like oil paints. Not surprisingly, the very pale colours are the cheapest (Series 1) and the brightest colours with metallic 'veining' are the most expensive

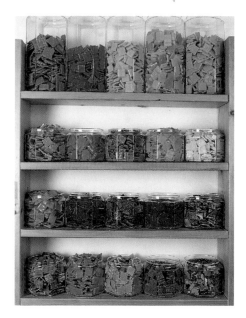

A selection of vitreous tiles

(Series 4). For chemical reasons, Candy Pink makes it to Series 5 all on its own.

To soak off the backing paper, place the sheet of tiles in a basin of warm water. After a few minutes, the paper will float off. Remove the paper and rinse the tiles in more warm water. Put them into a colander to drain and finally spread them out onto old dry towels, separating the colours as you go. Each colour can then be given its own jar and the end result is a studio which looks more like a sweet shop than an artist's studio.

A selection of ceramic tiles

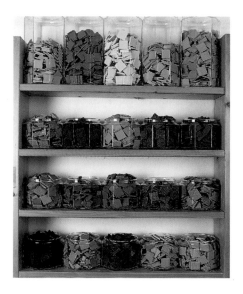

Alternatively, vitreous can be purchased in large 25 kg (55 lb) boxes, sold as mixed 'scrap' for about one third the price of the tiled sheets. There is nothing wrong with these tiles and they are soon sorted out into their jars. In fact it is a good idea to always have a mixed box around as they often contain colours that are not widely available or are from a different 'batch' to the one you have bought – the same colour sometimes being a slightly different hue.

• CERAMIC. All types of ceramic can, of course, be broken up and incorporated into a mosaic. It is very useful, though, to be able to buy sheets of ceramic tiles in various consistent colours and to know that you won't run out of any particular colour. Cinca is the brand name of one such type of unglazed ceramic tile made in Portugal but exported around the world. It comes in sheets of 14 x 14 tiles, each square measuring 23 x 23 mm (1 x 1 in). Because Cinca is so much heavier than vitreous glass, the glue binding it to the backing paper is stronger and takes longer to soak off. Even then, the tiles tend to stick together while drying, so it is advisable to spread them out on the towel so that they don't touch each other.

The range of ceramic tiles is good and there are usually 25 different colours to choose from. The main difference between vitreous and Cinca is that vitreous is made of glass and is therefore shiny and reflective, whereas Cinca is an un-glazed (non-reflective) ceramic. This can be used to good effect by placing an area of one next to the other; the vitreous will appear to come forward while the Cinca will appear to recede, thus a Cinca-mosaiced background will allow a vitreous or smalti subject to stand out.

Cinca tiles don't have a 'right' and 'wrong' side which means that you have the added advantage of being able to flip them over if you wish. As you work, you will appreciate how advantageous this is.

If the mosaic is made entirely of Cinca then the effect will be a calm one, reminiscent of Indian mosaics (see Gallery piece 'Resting Plaice').

Cinca is excellent for floor mosaics as the tiles are completely flat, and if set into a solid floor, can withstand the weight of a person walking across it.

• **SMALTI** is the Roman word for 'melt'. Smalti tesserae are hand-made in Venice and until recently there were only three families still making it. The recipes and techniques have been kept secret and handed down from father to son through the generations. Glass is melted in a cauldron and then poured out onto a metal sheet where it is pressed down like a pizza. This is then sawn up into little briquettes about 2 x 1 cm ($\frac{3}{4}$ x $\frac{1}{2}$ in). It is supposed to be used with the sides uppermost, emphasizing its rippled surface. Tiny air bubbles are sometimes visible, which is not a mistake but moreover part of its intrinsic quality. It can be bought loose by weight in an 'irregular mix' 25 kg (55 lb) box in much the same way as vitreous. In amongst the mixed assortment you will find tesserae that have a curved edge – these are the edges of the 'pizza'. Although purists would argue that these should not be used, I find them invaluable, as in the case of the Scallop Pot (see pages 68-9), where rounded edges are a great help.

Roman mosaics, though made mainly of natural stones, do sometimes contain the odd bit of smalti – usually bright colours like orange or blue, but it was really the Byzantines that made the material their own, creating entire wall mosaics out of it. Needless to say, being hand-made, smalti is very expensive. Despite the price, it makes a lovely addition to any mosaic and can be incorporated in small quantities.

Because of its uneven surface you do not need to grout smalti when working direct. The theory is that it self-grouts. As you push the smalti into the tile adhesive, so it is forced up between the gaps in the smalti (see page 68).

Using smalti indirect is no problem. Although it has a different thickness to vitreous glass tiles, in the case of indirect mosaic, this does not matter because the final face of the mosaic will be flat.

• **GOLD AND SILVER LEAF TILES** Gold and silver smalti have real gold or silver leaf in the glass tile. 'Ripple gold' and 'ripple silver', where the top surface of glass is undulated to create a rippled effect, are also available. Not surprisingly, these are the most expensive tiles of all. Both can be used upside down – the gold is a shiny green underneath, and the silver a shiny blue. Despite the cost, even when used sparingly, they can lift an otherwise lacklustre mosaic.

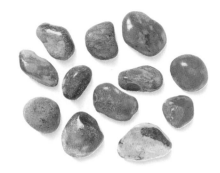

Assorted pebbles

• **FOUND OBJECTS** Roman mosaics were made of natural stone cut up into small cubes. Natural stone and marble are still used extensively in mosaics throughout the world. It is also possible to use found objects such as beads, buttons and shells; in fact, anything that can be combined with anything to make a cohesive whole.

Anyone who has ever played with pebbles on the beach (and who hasn't?) will immediately recognize the attraction of pebble mosaics. The Alhambra in Granada, Spain, is one of the most impressive places to see pebble mosaics, where they line the Moorish gardens of the Generalife.

What surprises most people is the fact that the amount of pebble visible above the cement is only the tip of the iceberg. The pebbles can be inserted straight into a bed of wet sand and cement, but if you intend to walk on your finished pebble mosaic it is worth making a simple mould and laying the pebbles indirect into a bed of sand (see the Pebble Mosaic Paving Slab on pages 48-51).

It is horrifying to see broken bottles on the beach. However, glass worn down by the motion of the sea is very pleasing and a treasure to any self-respecting mosaic artist. Likewise, broken crockery is a wonderful material to use for mosaics (see pages 58-9 and 70-3). Indeed, some mosaic artists have made this medium their own.

SAND
Some of the projects in this book include sand in the list of materials. I usually use plain builder's sand or, occasionally, sharp sand. Never use sand straight off the beach because it contains salt, which is corrosive.

Assorted smalti

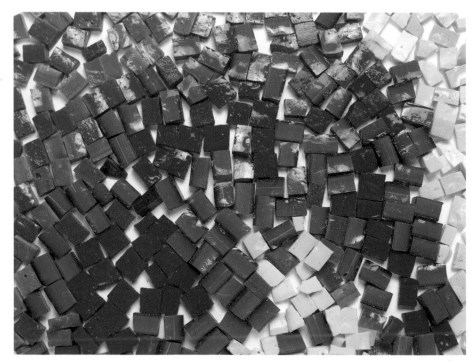

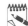

CUTTING TECHNIQUES

Before you begin cutting vitreous glass, consider the mosaic tiles. Each tile is 2 cm (¾ in) square with a flat face and an uneven 'ribbed' face. The ribbed surface acts as a key to take the glue while the flat surface always goes uppermost when working direct and will become the final surface of your mosaic. Each tile will cut into four basic mosaic pieces or tesserae, whose average size will be 1 cm (⅜ in) square, i.e. 10,000 per square metre.

A single piece of mosaic is called a tessera which comes from the Roman word meaning a cube. Traditionally, Roman tesserae were small 1 cm (⅜ in) cubes of natural stone cut down from large pieces of stone using a hammer and hardie. The hammer used (see below) is a small, thin, pointed one, rather like a jeweller's or geologist's hammer. A hardie (see below also) is a chisel embedded in wood or cast into a lump of concrete with its cutting edge uppermost. Although our mosaic pieces are not always cubic, the word tessera has been adopted through the ages.

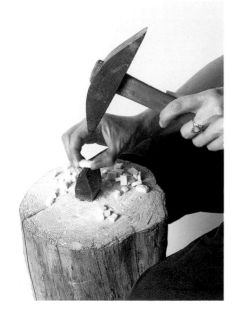

Hammer and hardie

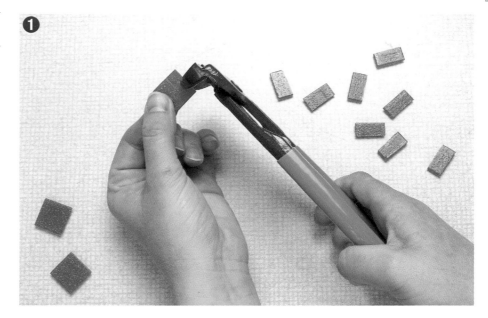

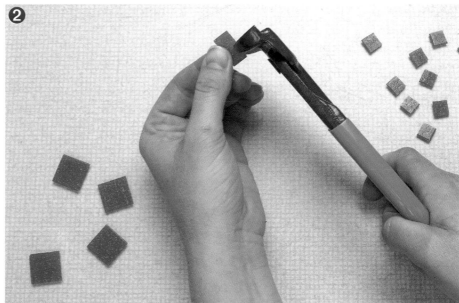

CUTTING A TILE INTO HALVES
① The nippers only have to crack the tile, so you need only place the tile about 4 mm (¼ in) into the jaws, halfway down the edge of the tile.

Apply a small amount of pressure to the handles and you will find that the tile will crack in two.

CUTTING A TILE INTO QUARTERS
② Pick up one of the halves and make a bridge with it across your index and middle finger, securing the tile with your thumb. Place the nippers half-way down and 4 mm (¼ in) in and apply a small amount of pressure to the handles again – the rectangle will crack into two small squares. Repeat.

You have now made four basic 1 cm (⅜ in) square tesserae out of one tile. (Even if one is bigger or smaller than the other three, they will still average 1 cm [⅜ in] square.)

CUTTING LONG, THIN LINES

③ Place the nippers further into the tile, say, about halfway in. Three or four thin lengths can be made out of each tile. The tiles sometimes have a tendency to shatter when you do this, so don't blame yourself if it takes a few attempts and some wastage before you achieve what you want.

CUTTING WEDGES

While laying a line of square tesserae next to each other will give you a straight line, to achieve a curved line, the tesserae should be cut at a slight angle into wedges. The closer the angle of each wedge is to 90 degrees, the softer the resulting curve will be when they are laid together.

In the course of cutting a pool of tesserae, you will naturally end up with a large percentage of wedges, anyway. If you are mosaicing a curved line, you can select these from your pool. ④ To cut wedges on purpose, halve the tiles as described above, but when you come to dividing them into quarters, place the nippers at a slight angle to the vertical before applying the pressure to the handles.

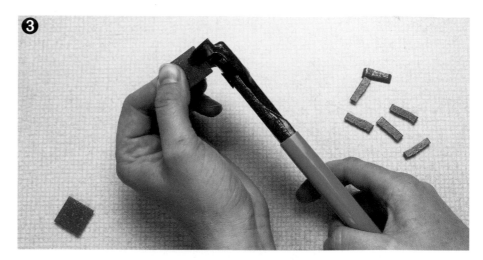

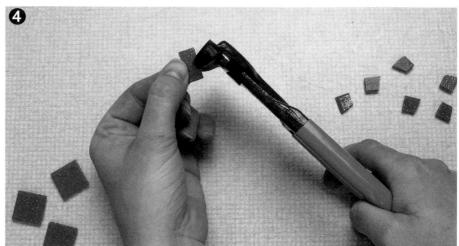

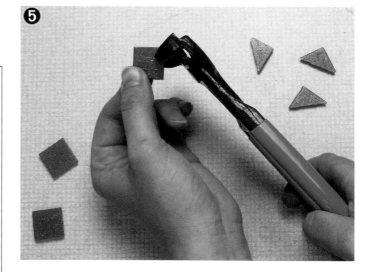

HEALTH AND SAFETY INSTRUCTIONS WHEN CUTTING VITREOUS GLASS

• Work in a well-ventilated room.
• Always wear safety spectacles and a face mask.
• When you are cutting the tiles, don't allow anyone to come near you, unless they are also wearing mask and eye protection.
• Use a dust pan and brush to sweep up all the little glass shards. Never use your hands as you may cut yourself on a glass splinter.
• Keep your work surfaces clean at all times. Sweep up or vacuum after each session.
• Keep glass particles away from food and drink, children, pets and wild animals.
• To keep all the glass waste under control when cutting tiles, you may like to work with your hands, nippers and tiles inside a clear plastic bag.

NIBBLING

⑤ 'Nibbling', or shaping, an individual tessera to a definite shape such as two small triangles from one square tessera, is achieved by placing the jaws of the nippers all the way along the diagonal.

Always try and keep hold of both halves of the tile as you cut it.

6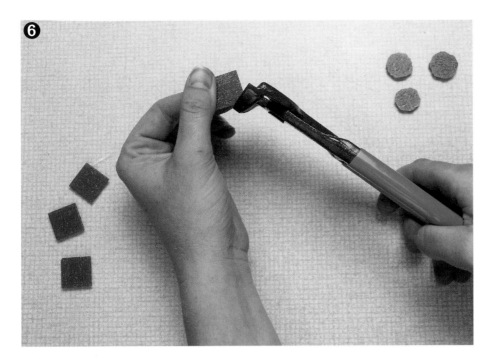

7

CUTTING A MOSAIC 'EYE'

⑧ To make the iris, first cut a blue (or brown or green) tile into a circle. Then cut it in half and in half again, laying the quarter circles down on the table so that they still fit together. If any of the quarters shatter, start again. Next, nibble the centre out of each quarter circle. Glue the four pieces back down in their rightful place. Now cut a black tessera for the pupil. Make it small enough to fit inside the iris and glue it in place. To make the white of the eye, use the nippers the 'wrong' way round and cut a curved line (this may take several attempts!), and then cut around the curve to create crescent moon shapes. Repeat four times and glue in place around the iris. This completes the eye.

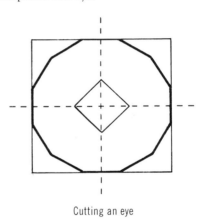

Cutting an eye

CUTTING A CIRCLE

⑥,⑦ A circle can be achieved by cutting each corner twice at 30 degrees and 60 degrees to the side edge. Place the jaws of the nippers right across the tile when you make these cuts. Don't worry if your circle is not perfectly circular, what we are creating here is a man-made piece of work; if you want perfect circles, buy them! (They are called beads!)

If you cut a 1 cm (³⁄₈ in) square tessera in half you will notice that one half will stand up and the other one won't. This is because the unstable one has come from the edge of the tile and so only has a small base. Despite this fact, you may well find that in

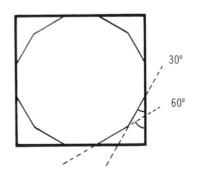

Cutting a circle

some cases this is the only piece that will do. If that is the case, simply glue it down and prop it up with an unglued tessera until the glue dries.

8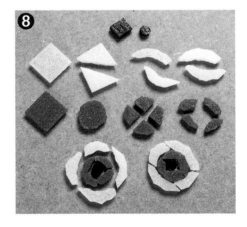

Cross-section of a tessera cut into eighths. The inner eighths (A) are more stable than the outer eighths (B) owing to their wider base.

MOSAIC TECHNIQUES

DIRECT MOSAIC

There are two basic methods of making a mosaic – direct and indirect. A direct mosaic is one where the tesserae are glued directly onto the surface that you are mosaicing. The tesserae are glued the right way up, the uppermost surface becoming the final surface of the finished mosaic. The advantage of working direct is that you can see what you are getting at all stages of the creative process. The resultant mosaic can be transported and exhibited and if you move house, you can take it with you. The disadvantage of direct mosaic is that the final surface is not completely flat and is therefore not suitable for floors or other circumstances where a flat surface is required, such as a table top or work surface.

A direct mosaic panel on medium density fibreboard (MDF) is only suitable for indoor use. If an external mosaic is required, then it is recommended that you work indirect (see opposite).

• **PREPARATION.** Before starting to lay tesserae, it is a good idea to cut up a handful of tiles and build up a small pool to choose from. If you place each colour on a separate, small piece of paper, then not only will you be able to work in each colour when you need it, but clearing away will also be made easier by simply inverting the paper, pouring the tesserae back into its jar.

It is often said that making a mosaic is like doing a jigsaw puzzle. This is a remark that is guaranteed to infuriate any self-respecting mosaic artist. Is painting someone's portrait in oils like painting by numbers? The fact is, that a jigsaw is a puzzle, with a pre-determined solution. No matter how good or bad you are at solving the puzzle, the end result will always be the same. This is certainly not true in mosaic where the result would never be the same, and making a mosaic definitely involves the creative process. That said, it is true that when you select a tessera from your pool of tesserae, you have to look for the correct shape which has the right angle to the line that you are trying to make. To help yourself, make the distance between the pool of tesserae on the paper and the mosaic as short as possible. I often place the paper on the mosaic, but you may feel that you need to see the entire piece at all times.

• **GLUING DOWN TESSERAE.** The glue dispenser is designed to release a small quantity of glue at a time, so only cut off the very tip of the nozzle.

If you are new to mosaic, it helps if you 'butter' each tessera individually until you become more experienced. As you become more confident, you can run a 'bead' of glue along the line that you are about to mosaic.

Be generous with the glue, but not to the extent that it squidges out over the top of the tesserae. The PVA is meant to hold the tesserae in position until you grout the finished mosaic, so you need to ensure that there is still sufficient room for the grout to do its job, too. If the glue dispenser empties, you can top it up by decanting from a larger pot of glue.

Spaces between the tesserae are a necessary part of the mosaic. The spaces, or interstices, that they create when grouted create the flow or *andamento* of the finished mosaic. The grout when set, is very strong and will hold the tesserae in place, preventing any side to side movement. The size of the gap you leave between tesserae really depends on your personal style of working. I work very 'tight' and find it difficult to leave a decent gap. Sylvia's work is much more precise with neat spaces between each tessera.

• **MOSAICING A STRAIGHT LINE OF TESSERAE.** Draw a straight line with a pencil and try and mosaic a line of tesserae along it. You will soon see that it is a bit like steering a car – if you are slightly out at the beginning you don't notice, but 100 yards further down the road and you are driving on the wrong side! ① Try and 'steer' along the line by choosing each successive tessera so that the angle between the line and the previous tessera is the same. If your attempt at a straight line was a success, it was due to the fact that the angles were correct. Indeed, if all the angles were 90 degrees, then you will not have experienced any difficulty; only when the angle varies, do you have to choose a tessera with the same angle in order to compensate and steer back on course.

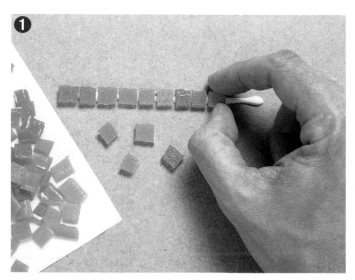

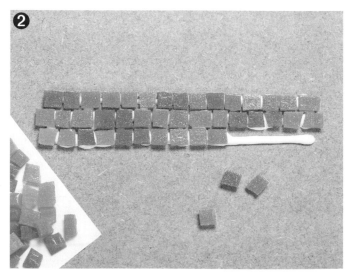

It will soon become apparent that as well as the line you are working to, it is equally important to leave yourself a straight line for the next row of tesserae. Thus, like ploughing a field, you need to keep on track and try and think ahead. ② If a tessera looks good next to its neighbours but juts out below the bottom line, simply nibble it down to the same length. If you don't do this, you can correct things on the next row by placing a thinner tessera next to it, putting yourself back on course. If you don't compensate, you may well find matters getting progressively worse with each subsequent row.

• **MOSAICING A CURVED LINE OF TESSERAE.** The same is true when mosaicing a curved line – if you try to leave a right angle to the curve each time, then it all becomes much easier. Not surprisingly, what you end up with are a series of wedges that steer themselves around the curve ③.

INDIRECT MOSAIC
When you buy a sheet of mosaic tiles, you will see that the tiles are spaced apart on the backing paper, the gap allowing for the finished grouting when being used for swimming pools. The reverse of the tiles (the face not attached to the paper) are 'ribbed' to allow cement to be buttered to them to 'key' them so that they can be applied to the rendered wall. When dry, the backing paper can be soaked off and the tiles grouted. This is the basic principle of an indirect mosaic.

When a flat surface is required, such as a floor, a tabletop, a swimming pool or a work surface, the mosaic needs to be made indirect. An indirect mosaic is one where the tesserae (vitreous, smalti, or whatever material you are using) have been laid face down onto paper using a water-soluble adhesive. Because the surface of the paper is flat, the resultant surface of the mosaic will also be flat. Working indirect also means that if working on, say, a swimming pool, the mosaic artist can work in their studio instead of having to travel to be 'on site'. If you wish, you can cement the papered mosaic to a board and then stick it to a wall (see the Frog Splashback on pages 60-3).

When set into cement or concrete, an indirect mosaic is suitable for external use and will last not only a lifetime, but if the Roman mosaics are anything to go by, for centuries to come.

Incidentally, there is much debate as to whether the Romans worked indirect or direct. In my opinion, the very reason why Roman mosaics were designed around 'emblemata' (circular pictures in the centre of a larger area containing a background and border) is precisely so that the master mosaicist could work comfortably in a studio on the indirect insertion, whilst the poor apprentices battled it out on their hands and knees working in the direct method on site.

• **WAXING A BOARD FOR AN INDIRECT MOSAIC.** I once had the embarrassing experience of delivering

a series of mosaics half way across the country only to find that I couldn't remove the paper from the board! Because I had worked on them slowly over a period of time, the wallpaper paste had soaked through the stretched paper and adhered to the board. There was no alternative but to return home and spend the following week transferring the mosaic, piece-by-

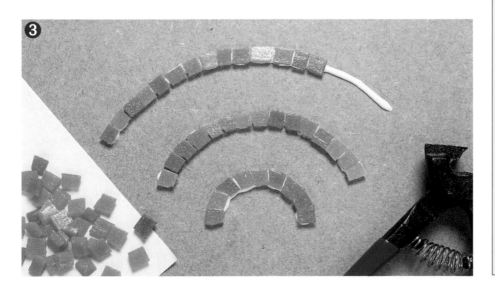

piece, to a board which had had beeswax rubbed into the area where the mosaic was to go. Needless to say, I now only use waxed boards.

To wax a board, draw a line 5 cm (2 in) all around from the edge of the board. Rub beeswax into this internal area (you can make do with rubbing a candle over it if you wish). Only wax the 'mosaic image' area; the surround needs to be kept wax-free so that the gummed paper tape will stick to it. You are now ready to stretch your paper.

• **STRETCHING A SHEET OF PAPER**
The sort of paper that is ideal for stretching is the thick brown craft paper sold in stationer's shops. The paper has a smooth side and a ribbed side. Although it is largely a matter of choice, I prefer to lay the ribbed side of the wrapping paper uppermost so that the tesserae 'key' to the paper better.

Cut the paper 2.5 cm (1 in) larger all around than the waxed mosaic area that you are about to work (see Roman Paving Slab on pages 52-5). Then tear off four lengths of 5 cm (2 in) wide gummed paper strips from a roll that can also be purchased from your local stationery supplier.

Wet the wrapping paper by running it through a bath of cold water. Then lay it down on the waxed board and hold in place while it dries out with the gummed paper strips that have also been wetted. As the paper dries, it will shrink and the end result will be that the paper is stretched taught and held down on the waxed mosaic board which can then be reused indefinitely.

• **GLUING DOWN TESSERAE FOR AN INDIRECT MOSAIC.** Any water-soluble glue or gum can be used (see page 9). I recommend wallpaper paste as it is cheap and you can mix it to the quantity and viscosity that you prefer. Use the glue sparingly as it only needs to act as a temporary fixing. Too much glue will make the brown paper buckle, but if you have stretched it properly then the buckling will not be too great. In any case, it will shrink back again, but make sure that your tesserae have not been laid too close together otherwise they will get 'scrunched up' when the glue dries and the paper re-stretches.

HINTS ABOUT DESIGN AND CHOOSING COLOURS

• Keep your design simple and uncluttered. Make sure that you have a strong tonal contrast between the subject and its background so that the subject stands out visually, even from a distance. Be kind to your mistakes. If you get it wrong, you will get it right next time.

• Remember that tonal contrast between the subject and the background is of vital importance. If the two are tonally similar, then from a distance the subject will disappear.

• It is a good idea to limit the colour palette, at least until you are an experienced mosaicist. One or two carefully chosen colours are usually more effective than a whole spectrum.

• Don't be frightened of having plain areas of mosaic. For example, look at the Frog Splashback on pages 60-3. The plain area is necessary to stress the fact that the frog is swimming. On your initial design, plain areas look boring, but when mosaiced they become a necessary part of the overall piece, emphasizing that this is a mosaic that we are looking at. If the entire picture surface is busy, this effect is lessened somewhat.

• If in doubt, simplify. Consider the silhouette of your subject, say, a gecko. If it works as a silhouette, then it will certainly work when it is 'filled in'. If the silhouette is messy and incongruous, the finished piece may not look good either. This is why creatures such as fish, geckoes or butterflies, which have clear outlines, are so popular with mosaic artists.

• Think in terms of whether your colours need to be 'warm' or 'cool'. Basically, a warm colour is one that contains red, while a cool colour is one that contains blue. Thus purple, which is a mixture of red and blue, can be warm or cool depending on whether there is a predominance of red or blue. I find that this can help enormously when I am having trouble choosing a colour, say for a background. If I want the overall effect to be warm I can choose, say, a caramel or a soft pink. If cool, then a pastel blue or green may be more appropriate.

GROUTING

Anyone who has ever had the pleasure of mixing cement will have no trouble grouting.

Buy the finest grout available. Powdered grout is available in grey, white, ivory and brown. It is also available in a variety of colours 'ready mixed' which is fine, but has a shorter shelf life. This can be greatly improved by cutting out a circular piece of paper and laying it on the surface of the grout that is left in the pot to prevent the air from getting to it and drying out.

Always follow the health and safety instructions on the packet. If you are using powdered grout, you can colour it at the 'dry' stage by adding coloured powder paints and/or up to 50 per cent fine sand. I recommend that you stick to plain grey grout nine times out of ten. The grout delineates the tesserae and if it is brightly coloured, it can distract or even overpower the effect of the mosaic. I occasionally use brown grout if the overall colour of the mosaic is 'warm' and brown seems to be the harmonious choice. Although I don't often use brightly coloured grouts, I have seen them used to excellent dramatic effect, especially in jazzy, abstract mosaics.

To mix the grout, wear rubber gloves and make a 'volcano' by pouring out the grout onto a flat piece of scrap wood (hardboard is ideal) and make a 'well' in the centre. Gradually add water to the well and mix thoroughly with a small hand trowel. The mixed grout should be of a 'mud pie' consistency – if it is too stiff, it won't flow into the gaps, if it is too wet it will wash out of the gaps when you clean it off.

Starting on the vertical edges, spread the grout with a 'squeegee' or tile grout spreader. Then grout the top surface of the mosaic, running the grout spreader across the surface in all directions in order to fill the gaps thoroughly.

Wipe off the excess grout from the sides and top surface using a damp cloth. Sometimes in a direct mosaic, a few of the tesserae are set lower than the rest and so become submerged by grout. Once grouted, reveal any such tesserae using a penknife or other

suitable tool. Take some trouble at this stage; it is much harder to remove grout once it has set.

The drying of the grout is a chemical process and takes about 24 hours. There is nothing to be gained by placing the mosaic in the hot sun to speed up the drying time.

You will notice that the finished mosaic lacks some of the shine it had before it was grouted. This is partially due to an unavoidable scum of grout remaining on the surface. In a couple of days, when the grout has set, give the mosaic a scrub with a liquid floor cleaner using an abrasive sponge pad.

If you are making a direct mosaic plaque, screw in 'D' rings or mirror plates, available from your local ironmongers, and hang it in a suitable place – somewhere that allows the light to play on the surface.

WHERE TO BEGIN

To transfer a design from an existing template or illustration, place carbon paper, ink-side down onto the surface you are about to mosaic. Trace off your chosen design onto tracing paper and place it on the carbon paper. Firmly trace over the design with a sharp pencil to transfer it (see also page 74).

If you are a beginner working on a project to, say, mosaic a straightforward plaque such as the Gecko on pages 38-41, the temptation is to start on the Gecko's face. In fact, there are three good reasons why it is best to start on the border first.

First of all, you will get useful practice at cutting the tiles into tesserae. If a tile accidentally cuts at an angle that is not straight, you can compensate by cutting another to match this angle.

Mosaicing straight lines. Compensate for ill-cut tesserae by cutting other tesserae with angles to match.

Secondly, when the time comes to grout the finished piece, it is the edge tesserae that take the biggest knocks with the grout spreader. If any tesserae are going to fall off, it is invariably these ones. Those in the middle have their neighbours to support them, the edge ones don't. So if you have mosaiced the edge first, you will be certain that the glue has well and truly set and that these tesserae are firmly in place.

And lastly, before mosaicing the edge tiles, the work surface has to be completely clean. If there are any glass shards under the board from where you have been cutting, the board will not rest flat. If you begin to mosaic the edge first, before you have done any cutting at all, there is no need to clear and clean the work surface, it is ready to make a start. Remember to place a sheet of paper or newspaper underneath the MDF panel to prevent it from sticking to the work surface.

MOSAICING THE IMAGE

Having mosaiced the border, you are now ready to start on the image itself. You will soon find that it is a lot easier to mosaic next to tesserae that have already set. So, if you are mosaicing, say, an eye, it is a good idea to initially place the pupil in position and let it set for half an hour or so (if you are using PVA). When you later add the iris, there is no possibility of the pupil being disturbed. This is only necessary on very precise areas such as facial features, where you want to capture a specific expression and the exact placing of a single tessera can be vital.

Always mosaic the object that is closest to you in visual terms. This is because, however hard you try, the mosaiced line will never precisely follow your pencil line. Imagine you are mosaicing a fish swimming through water. If you worked the *opus vermiculatum* (see right) of the background first, this would dictate the outline of the fish, which is obviously more important. Thus, if a fish is swimming through seaweed, for example, the seaweed needs to be worked on first, then the fish, and finally the watery background.

GLOSSARY OF MOSAIC TERMS

Andamento The generic word to describe the general 'flow' of the mosaic.
Interstices The spaces between the *tesserae*.
Opus musivum See below.
Opus regulatum A Roman mosaic technique whereby regular, square tesserae are applied in straight rows. The result is like a 'brick wall' pattern and was frequently used to fill expanses of background.
Opus sectile When a part of the mosaic, such as a head, consists of only one part then this part is known as *opus sectile*. If the whole area of the mosaic is covered in this way the resulting effect is more akin to stained glass or marquetry.
Opus tessellatum A Roman mosaic technique whereby regular, square *tesserae* are applied in a rectilinear arrangement. The resulting uniform 'grid' design was most frequently used to fill expanses of background. You would reasonably expect this to be the most common *opus* for background work, but in fact, because the tesserae are irregular, the rows rarely meet up on two axis. Thus *Opus regulatum* is the most common *opus* used for background work.
Opus vermiculatum A Roman mosaic technique whereby regular, square *tesserae* are applied in a row around the main mosaic motif to create a halo effect and emphasize the setting lines of the design. *Vermis* is the Latin word for worm (as in vermicelli!), so you can think of this as the 'worm' of *tesserae* that outline the main figure(s) (see 'White Flamingo' mosaic on page 20).

If the *opus vermiculatum* is continued outwards to fill a larger area then this area becomes **Opus musivum**, such as in the background of the Gecko Plaque on page 38. This is the most rhythmic and lyrical of all the *opus* and literally it means 'pertaining to the Muses'.
Tesserae 'Tessera' is a Roman word meaning cube (pl. *tesserae*). These cubes are the basic building blocks of mosaic. The term embraces diverse materials, including marble, ceramic, glass and pebbles.

GALLERY

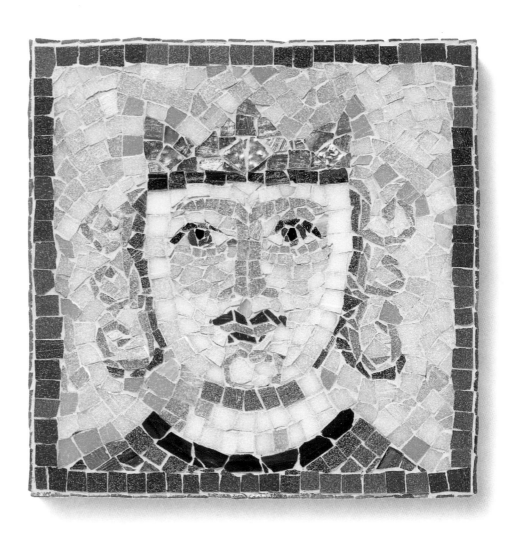

The King's Head

This was Kim's first attempt at mosaic, made when she came on one of my courses. The human face, though so familiar to us all, is surely one of the most challenging subjects to achieve successfully in mosaic. Skin tones are particularly difficult, given that the limited range of colours means that one's palette is so restricted. The fact that Kim succeeded first time, and so perfectly, is a testament to her great artistic ability. The gold smalti, though used sparingly, lifts the whole piece and leaves us in no doubt that it is a king that we are looking at. The wonderful stylization owes much to the Byzantine mosaics which Kim saw in the church of St Sophia in Salonika, northern Greece.

Designer and maker: Kim Williams
Size: 23 cm (9 in) square
Method: Direct
Medium: Vitreous glass and gold smalti

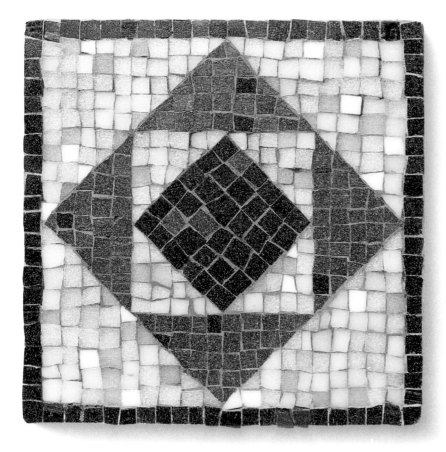

Roman Paving Slab

This simple but effective paving slab is derived from a Roman design. The diamond in the middle, with its *opus regulatum* flowing at 45 degrees to the rest of the mosaic, draws one's attention to the centre of the slab. This is an ideal design to repeat and make up as a chequerboard, reversing the black and white areas for each alternate square. Or, if you wanted to make a herb garden, you could leave each alternate square for earth, and plant with a different herb. Sometimes on Roman floors, different chequerboard designs are themselves arranged in a chequerboard pattern.

Designer and maker: Martin Cheek
Size: 25 cm (10 in) square
Method: Indirect
Medium: Vitreous glass

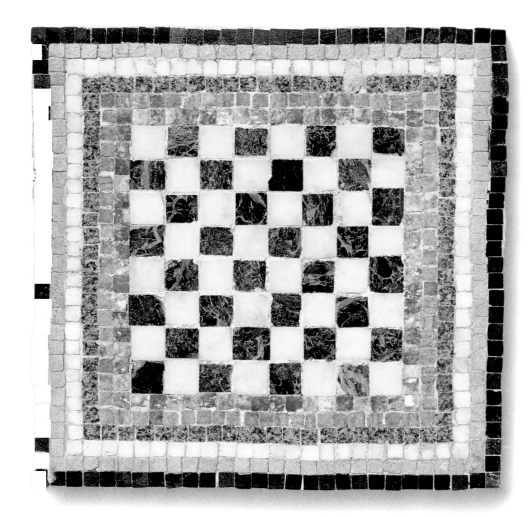

Chess Board

I am a keen chess player. I also collect and enjoy making my own chess sets and boards. The subtlety of marble is such that even a very basic design like this has its own natural beauty. In fact, as any chess player will tell you, a busy design is far too distracting if the grey matter is to do its work properly.

In this case, it is essential to make the mosaic indirect if you want to play on it, otherwise the pieces won't be able to stand up. Incidentally, the way to calculate if you have the right size pieces for the board is to lay the king on its side across the squares. The king's height should measure exactly two squares long.

Designer and maker: Martin Cheek
Size: 26.5 cm (10⅜ in) square
Method: Indirect
Medium: Marble

Abstract Mirror

This mirror is terribly simple in design but very cheerful. It would liven up any bathroom. The soft pastel greys are visually pushed back, allowing the red, orange and blue tesserae to stand out. White grout was used in this case, to keep the overall effect light.

Designer and maker: Kim Williams
Size: 26.5 cm (10⅜ in) square
Method: Direct
Medium: Vitreous glass

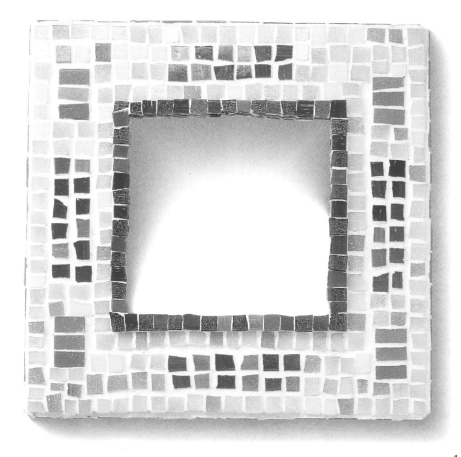

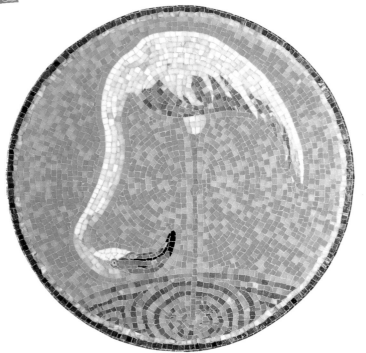

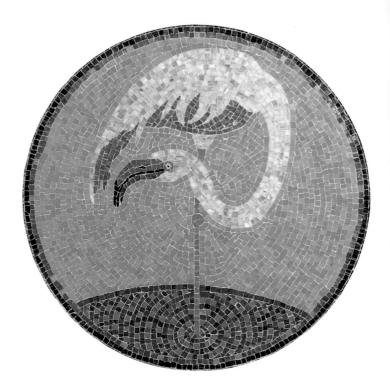

White Flamingo

The design for this mosaic was inspired by a visit to the zoo. On seeing the flamingo, my son remarked, 'Daddy – look at that bird sitting on a stick!'. Back home, I immediately drew the flamingo more or less as he appears here in the mosaic. The concentric circles of mosaic echo the ripples we saw on the surface of his pool.

Designer and maker: Martin Cheek
Size: 66 cm (26 in) diameter
Method: Direct Medium: Vitreous glass

Pink Flamingo

This plaque was commissioned as a companion piece to the White Flamingo and they now hang in coy, flirtatious splendour on the wall of a formal dining room in a city townhouse. I felt that the original flamingo was a male and so tried to make this one female and sufficiently different while at the same time obviously part of a pair.
This pair of flamingoes is a good example of how the *opus vermiculatum* 'cleans up' the edge of a subject (in this case, the flamingo), making a clean line and allowing the *opus* of the background (here, the water) to 'crash' into it rather than into the bird.

Designer and maker: Martin Cheek
Size: 66 cm (26 in) diameter
Method: Direct Medium: Vitreous glass

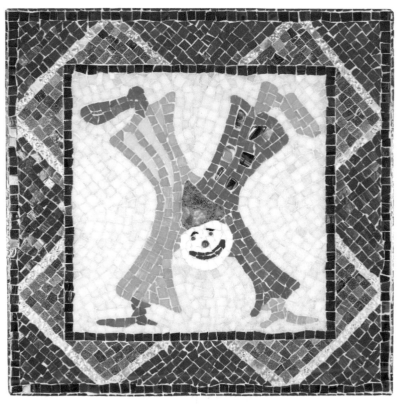

Tumbling Clown

This entire design is based on the shape of a cross – from the blue and gold border to the shape of the subject's spread limbs. The clown was drawn from life, inspired by a visit I made to the Moscow State Circus, which had a rather old-fashioned, 1950s' feel to it. The central X of the figure dictated the line of action of the background which radiates out from it, while the zig-zag border is very much part of the design and helps to emphasize the overall joviality of the piece.

Designer and maker: Martin Cheek
Size: 42.5 cm (17 in) square
Method: Direct
Medium: Vitreous glass, gold smalti
and natural Jasper stones

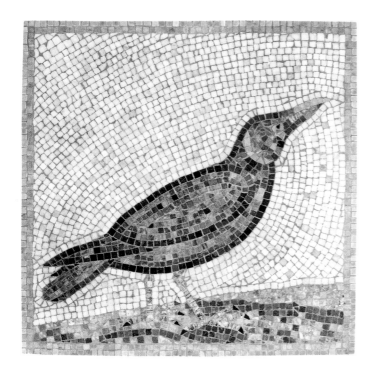

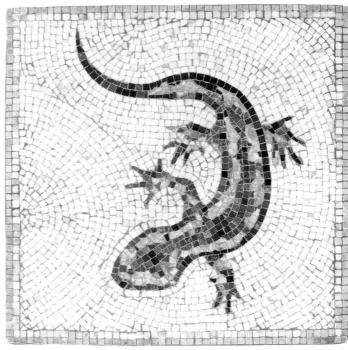

Carrion Crow

This crow is one of a pair of marble paving slabs. I chose this particular bird as a subject because I wanted to use a large area of black granite which contains tiny flecks of sparkling mineral. They catch the light in much the same way as the sheen on the feathers of the real bird sometimes does. I like the way such a simple design with its large, 'plain' areas allows the subtle changes in the natural stone to give the work its intrinsic beauty.

Designer and maker: Martin Cheek
Size: 46 cm (18 in) square
Method: Indirect
Medium: Marble and granite

Fire Salamander

The design for this paving slab is based on a live creature which Thomas found in a sewerage tank while on holiday in the Ardèche in southern France. Its jet black body had flaming 'Van Gogh yellow' patches and the pose shown here is one he kept for hours on end as he basked in the sun. I left the background deliberately plain and muted to show off the creature's bold colouring.

Designer and maker: Martin Cheek
Size: 46 cm (18 in) square
Method: Indirect Medium: Marble

Winged Horse

This design has a charming, deliberately naive and slightly airy quality about it, which is not surprising, as it was inspired by a child's drawing. The purple and gold border lend a rich quality to the piece and the positioning of the gold smalti 'dots' was crucial to that overall effect.

I like the challenge of taking a simple drawing, executed in about a minute, and trying to keep that immediacy and spontaneity, even though it takes three days to make as a mosaic.

Designer and maker: Martin Cheek
Size: 42.5 cm (17 in) square
Method: Direct
Medium: Vitreous glass and gold smalti

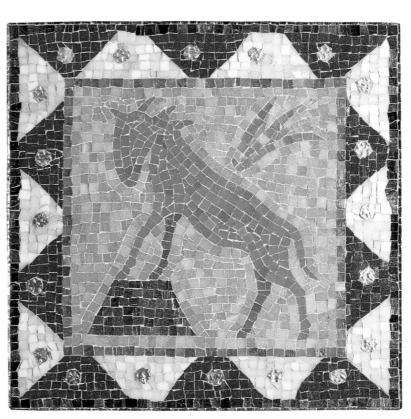

21

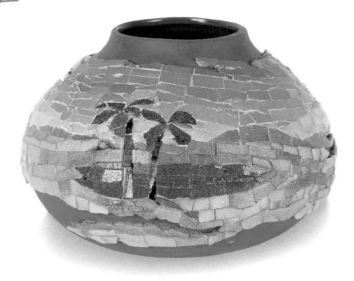

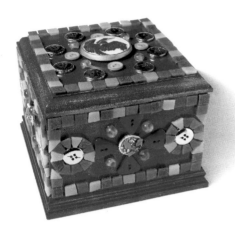

Palm Tree Pot

This colourful pot proves the point of how, when viewed from a distance, the different coloured tesserae fuse together and the mosaic can appear to come alive – or is it just a mirage?!

Designer and maker: Liz Sims
Size: 12.5 cm (5 in) high
Method: Direct
Medium: Vitreous glass

Button Box

This piece is a lively alternative to the Bead Box (see pages 36-7). Once again, the essential beauty of the buttons have been allowed to dominate the design. As with the bead box, if the entire box had been covered in buttons the finished effect would be overwhelming. So often it proves to be the case that 'less is more', particularly in the case of a mosaic, where the very nature of making an image from many small parts creates a rich, busy result. Limiting the palette, or in this case, the number of buttons, helps to combat this.

Designer and maker: Paul Hazelton
Size: 14.5 x 14.5 x 12.5 cm (5¾ x 5¾ x 5 in)
Method: Direct
Medium: Buttons and vitreous glass

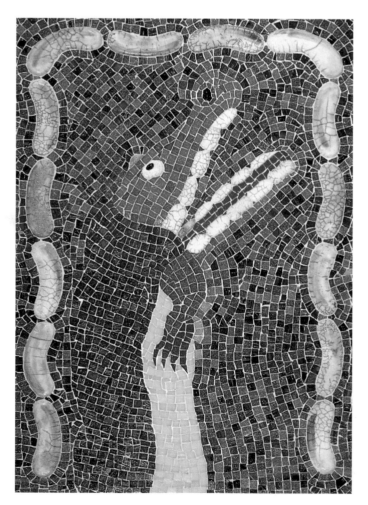

Crocodile and Sausages

This mixed-media mosaic was made to amuse my son, Thomas. Even as a small baby he loved to watch our friend Martin Bridle perform his Punch and Judy show. The idea of sculpting and Raku-firing a string of sausages as a border struck me as amusing. To make the sausages sing out, I chose the dark purple background you can see, but in doing so I lost the definition of the croc's back because it is the same tone as the purple background. If I were to re-make this piece I would choose a soft, pastel green for the background.

Designer and maker: Martin Cheek
Size: 44.5 x 61.5 cm (17½ x 24 in)
Method: Direct
Medium: Vitreous glass and
sculpted Raku tile sausages

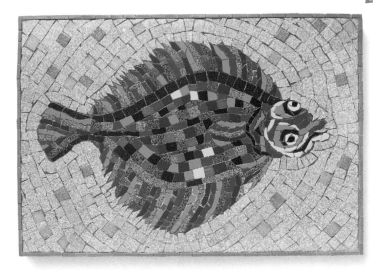

Resting Plaice

I don't often use the ceramic Cinca tiles in my mosaics, but I wanted to include one in the book, because I do like them in other people's work. Originally, I started with a blue ceramic background, but I remembered that flat fish are usually to be found lying on the sea bed as opposed to swimming through the water. The natural patina on the background tiles is a gift as it adds a sandy quality to the piece. I chose a plaice because I love the way that their orange spots sing out, so I used the shiny orange vitreous glass tiles to achieve this effect. The caramel glass tesserae peppering the background were added to echo the orange spots of the plaice itself.

Designer and maker: Martin Cheek
Size: 30.5 x 21.5 cm (12 x 8½ in)
Method: Direct
Medium: Ceramic Cinca and vitreous glass

Cat Firescreen

Kim Williams is a mosaic artist with a very strong sense of colour and design. Placing a cat on a mat in front of a roaring fire is a very witty idea for this firescreen. The colourful vitreous flames shine out because they are glass, in contrast to the non-reflective surface of the ceramic Cinca tiles which were used for the tabby.

Designer and maker: Kim Williams Size: 51 x 71 cm (20 x 28 in)
Method: Direct Medium: Ceramic Cinca and vitreous glass

Whiting Table

The starting point for this design was the way that, as part of their window displays, traditional fishmongers used to place the tail of whole round fish in their mouths, ready for the pot.
It was important to mosaic the dark line of the whitings's back neatly, as this line gives the piece its circular *andamento*. Long, thin tesserae were used to mosaic the delicate fins. Pieces of broken mirror juxtaposed with silver smalti, placed both right (silver) side and wrong (blue) side uppermost, were used to 'pepper' the background and give it sparkle.

Designer and maker: Martin Cheek
Size: 50.5 cm (20 in) diameter
Method: Direct
Medium: Vitreous glass, silver smalti and
broken mirror with Raku tile eye

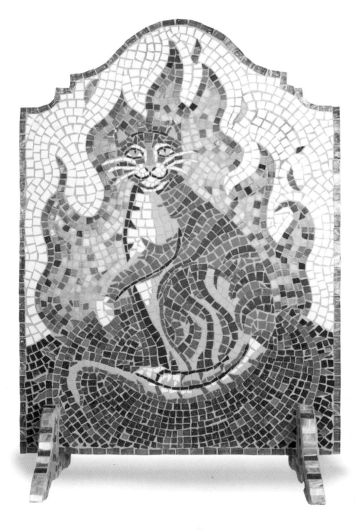

Peacock Butterfly

Whenever we need inspiration for good colour combinations, we can do no better than to turn to Nature and there are few more beautiful sights than the colours of butterflies. As its name suggests, the Peacock is the most multi-coloured of all butterflies and it was therefore a challenge to try to create it in mosaic. Even though my butterfly is many times bigger than an actual one, it was still very difficult to get the smalti intricate enough. If you try to paint a Peacock butterfly from life, you will notice that the colours seem to be different each time you look at them (it is remarkable to think that it is powder that makes up this wonderful effect) – purples transform to blues and then to greens, and, of course, the same is true when you try to mosaic one. Although I am still unhappy with the result, I believe that unless we strive to achieve perfection we will never even approach it.

Designer and maker: Martin Cheek
Size: 47 x 37 cm (18½ x 14½ in)
Method: Direct
Medium: Vitreous glass, smalti and broken mirror

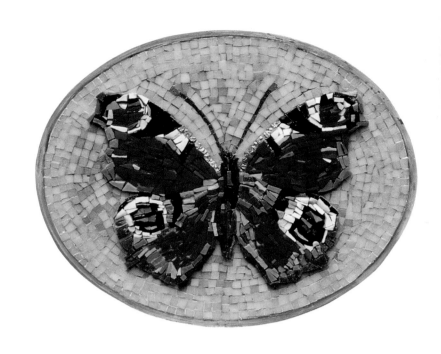

Indian Elephant

Sylvia was already a very accomplished mosaic artist before she came on one of my courses. I like to fire my own tiles and incorporate them into my mosaics. This idea appealed to Sylvia very much so she fired the intricate pattern of the elephant's blanket onto a pre-shaped tile. The colours in interior designer Jane Churchill's fabric 'Indian Summer' inspired those of this piece.

Designer and maker: Sylvia Bell
Size:50.5 cm (20 in) square
Method: Direct
Medium: Ceramic Cinca with a Raku tile

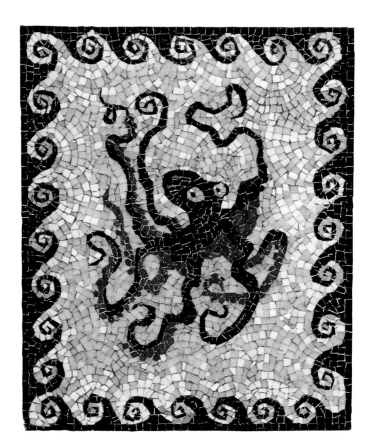

Dancing Octopus

'I marvel at thee, Octopus, if I were thou, I'd call me us'. OGDEN NASH

This short poem by Ogden Nash was the inspiration for this early work. I think that this piece shows that prior to being a mosaic artist, I was a puppet animator and even now, character and movement play a very important part in my work. In this piece I wanted to try to capture the way that the octopus seems to dance elegantly through the water. The design is also tipping a knowing wink to the Minoans and Mycaenaens, who loved to show similarly jolly octopuses on their ceramic pots.

Designer and maker: Martin Cheek
Size: 46 x 58 cm (35½ x 16 in)
Method: Direct Medium: Vitreous glass

Masticating Goat

Sylvia's goat is inspired by a Roman mosaic which she saw in the Bardo Museum in Tunis. The long ringlets of hair were especially appealing to Sylvia's sense of mosaic design. The few fronds of grass serve to echo the hairy quality of the goat's fleece.

Designer and maker: Sylvia Bell
Size: 61 x 51 cm (24 x 20 in)
Method: Direct
Medium: Ceramic Cinca and vitreous glass

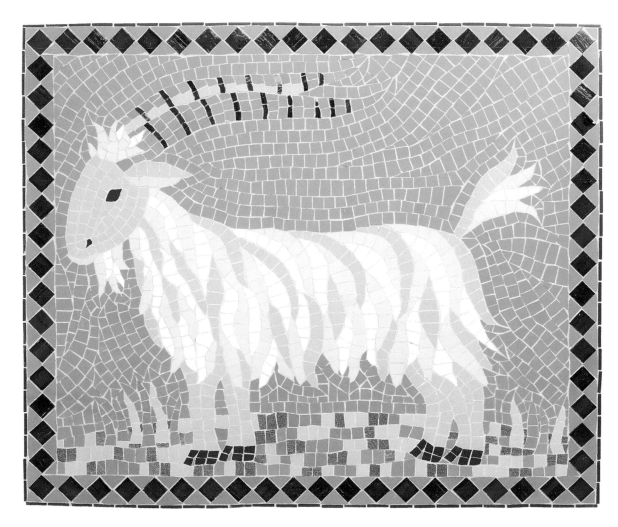

TRIVET

Liz Sims is a young mosaic artist with a strong sense for simple pattern and colour. Geometric designs such as this lend themselves very well to mosaic. The strong contrast between black and white set off by the mid-tone brown make this a very striking mosaic. Although simple, it is very important to be as neat as possible when making this sort of geometric mosaic. For this reason this trivet is an ideal practice piece.

Our trivet had a recessed top meant to hold a tile 5 mm (¼ in) thick. This means that the depth is 2 mm (¹⁄₁₆ in) deeper than the 3 mm (⅛ in) thick Cinca ceramic tiles. To overcome this we cut out a piece of 2 mm (¹⁄₁₆ in) thick skim ply the size of the top and glued it in position with fast setting two-part epoxy resin to make up the difference. The finished mosaic will now be flush with the edges of the trivet.

SIZE: 15 CM (6 IN) SQUARE
DESIGNER AND MAKER: LIZ SIMS

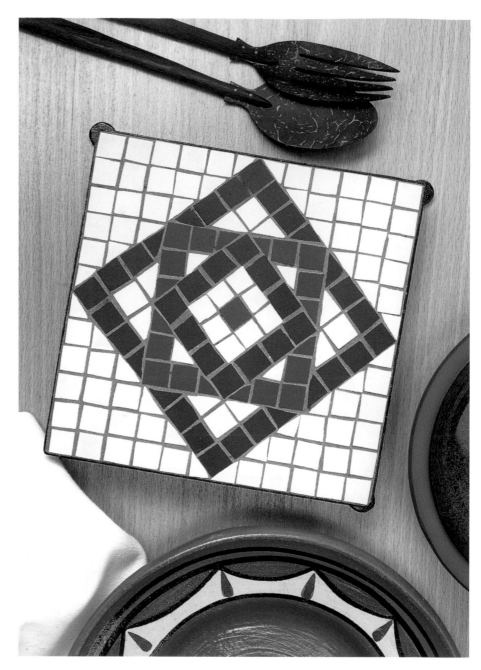

1 black (40 tiles)
2 brown (32 tiles)
3 white (180 tiles)

YOU WILL NEED

Metal trivet	Craft knife
2 mm (¹⁄₁₆ in) thick skim ply measuring 15 cm (6 in) square	Safety spectacles
	Face mask
Two-part, fast-setting epoxy resin	Rubber gloves
Sheet of A4 carbon paper	450 g (1 lb) of powdered grout
Template (page 74)	Bowl of water
Sharp pencil	Mixing board
Tracing paper	Trowel
Cinca ceramic tiles as shown left	Plastic grout spreader
Mosaic nippers	Cleaning cloth
125 ml (4 fl oz) wood adhesive in dispenser	Liquid floor cleaner
	Abrasive cleaning pad

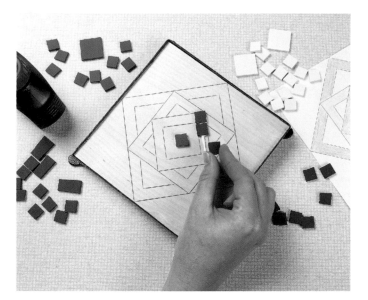

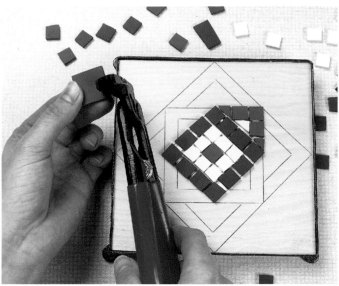

1 Transfer the design onto the skim ply as described on page 74. Cut a brown tile into quarters and glue one of the four tesserae in the centre of the design on the skim ply. Cut up some black tiles into square tesserae and mosaic the square border around the centre. Try to keep the tesserae the same size, as this will make the finished mosaic look neater. Allow small gaps of about 1 mm (1/16 in) between the tesserae; these will be filled when the mosaic is grouted and make the whole mosaic stronger.

2 Fill in the area between the brown and black tesserae with white ones. Continue to work outwards by mosaicing the next brown border, filling in the triangular corner gaps with white tesserae nibbled diagonally in half to form small triangles. The nibbling process may take a number of attempts before you get neat triangles. Don't worry, this is perfectly normal.

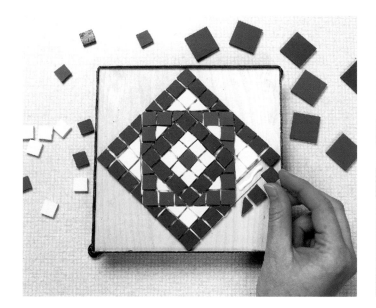

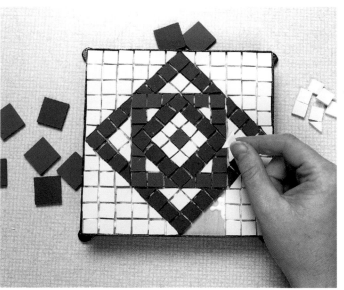

3 Continue working outwards, revolving the trivet as you work. Mosaic each border in turn. Try to achieve straight lines as you work. Although this design is simple, the lines need to be neat and straight.

4 Finally, fill in the four remaining triangles with white tesserae. Wait for three hours for the glue to dry, then grout and clean in the normal way (see pages 16-17). Allow to dry for at least two days before cleaning off the surface scum with the liquid floor cleaner and abrasive pad (see page 17).

STRAWBERRY MOBILE

The idea of making a mosaic mobile with miniature mosaics spinning round in space is an appealing one. One of the most attractive features of mosaic is the way that the light plays on its multi-faceted surface. Indeed, when someone talks about the 'three-dimensional quality' of mosaic, this is usually what they mean.

I thought that a mosaic mobile for the kitchen would prove not only an attractive, but also a useful, addition, keeping a baby amused while allowing the adults to get on with the cooking. Fruit or vegetables seem an obvious subject matter, very much at home in the kitchen or dining room. This idea can, of course, be adapted to any fruit or vegetable.

In this case, grout would spoil the bright effect of the colourful tesserae. Instead, I decided to glue the tesserae with two-part epoxy resin. I have used acetate as a temporary surface to work on; it simply peels off afterwards.

SIZE OF EACH STRAWBERRY:
5 X 7 CM (2 X 2¾ IN)
DESIGNER: MARTIN CHEEK
MAKERS: REBECCA DRISCOLL AND
MARTIN CHEEK

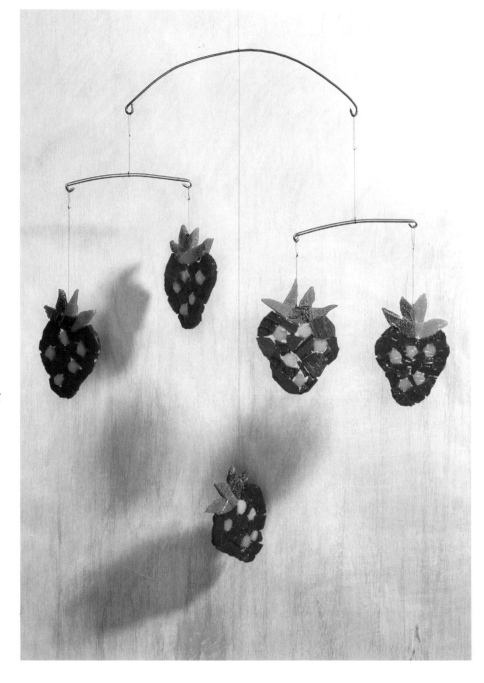

YOU WILL NEED

Paper	Safety spectacles
Tracing paper	Lollipop stick
Pencil	Cocktail stick
Carbon paper	Craft knife
Acetate	Two 30 cm (12 in) lengths of 2 mm (1/16 in) brass rod
Vitreous glass tiles as shown right	Long-nosed pliers
Mosaic nippers	Roll of 4 kg (8 lb) breaking strain fishing line or invisible thread
Two-part, fast-setting epoxy resin	
15 x 10 cm (6 x 4 in) piece of card	Hook eye

1	bright red (31 tiles)
2	bright yellow (8 tiles)
3	deep green (10 tiles)
4	scarlet (23 tiles)
5	light green (10 tiles)

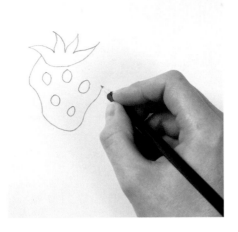

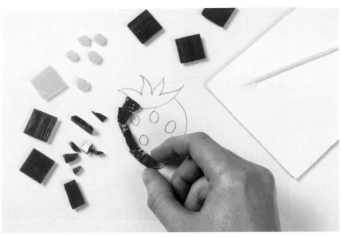

1 Trace the shape of the strawberry onto tracing paper and then transfer onto the plain paper using the carbon paper. Make three strawberries one way round and two the other way round.

2 Make the seeds by cutting each of the yellow tiles into four tesserae, then nibble each one into a small circle. Place the acetate over your design and begin to mosaic the key line, in this case the outer edge. It is important that each tessera is the opposite way round to its neighbour as it is only the bevelled edges that are going to be stuck together. When you are happy with the line, in a well-ventilated room, mix up a small amount of epoxy resin and use a cocktail stick to apply it to the edges of the tesserae. You need sufficient glue to form a bond but not so much that it spills over onto the top or bottom surface of the mosaic. A small amount of glue will inevitably squidge through, but don't worry about it – that is why the acetate is there.

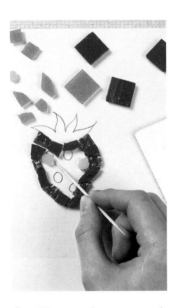

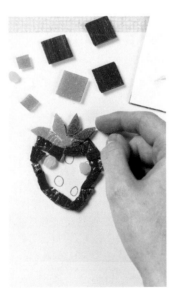

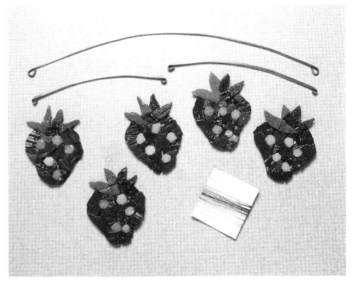

3 When you have mosaiced all around the outside edge, fill in the middle of the strawberry, remembering to incorporate the yellow seeds.

4 Finish off the strawberry by mosaicing the green stalk. Try to get good clean leaves finishing at a point. Leave a tiny hole at the top of each strawberry so that you can eventually thread them up.

5 Repeat for the other four strawberries. Leave to dry overnight for although the epoxy has a very quick 'working time' of about 10 minutes, the glue will continue to slowly harden over the next 24 hours. The next day, carefully peel the strawberries off the acetate, repairing any breakages and reinforcing any fragile joins with more epoxy, and leave to harden. Meanwhile, make the mobile frame by cutting up the brass rod into one long and two short lengths. Then use the long-nosed pliers to bend the ends of the wire into loops and wire up the fruit with fishing line.

FINGERPLATES

To have mosaics around the home is a real treat, but owing to their richness, too many can easily overpower a room. This does not necessarily have to be the case. The understated design for this project is more suggestive than descriptive and the subtle colour scheme makes for an harmonious, quietly pleasing result and makes an ideal gift. We have mosaiced the second fingerplate in a slightly different colour scheme, so that you can see what a difference a subtle change makes.

If you wish, you can ignore the screws and simply glue the fingerplate to the door with quick-setting epoxy resin. Use masking tape to keep it in place while the glue sets.

Size 30 x 7.5 cm (12 x 3 in)
Designer and maker:
Rebecca Driscoll

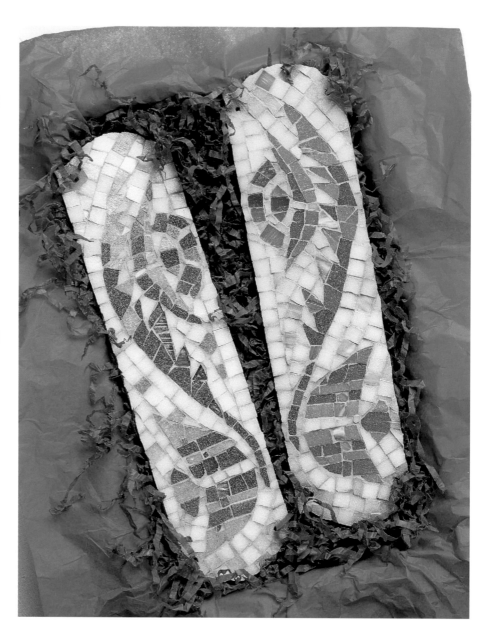

YOU WILL NEED

Sheet of skim ply 30 cm (12 in) square x 2 mm (¹⁄₁₆ in) thick	Sheets of newspaper
	Safety spectacles
Sheets of A4 carbon paper	Face mask
Template (page 74)	Rubber gloves
Sharp pencil	450 g (1 lb) of powdered grout
Tracing paper	Bowl of water
Jeweller's saw	Mixing board for the grout
Craft knife	Trowel
Metal ruler	Plastic grout spreader
Drill	Cleaning cloth
3 mm (⅛ in) drill bit	Liquid floor cleaner
Vitreous glass tiles as shown right	Abrasive cleaning pad
Mosaic nippers	Eight 2 cm (¾ in) screws
125 ml (4 fl oz) wood glue in a dispenser	

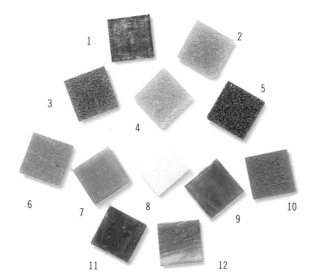

1 emerald vein (4 tiles)
2 mauve (6 tiles)
3 dark green (10 tiles)
4 mint green (12 tiles)
5 purple (3 tiles)
6 bright green (12 tiles)
7 candy pink (3 tiles)
8 soft pink (80 tiles)
9 pink vein (3 tiles)
10 green (10 tiles)
11 dark pink vein (2 tiles)
12 green vein (4 tiles)

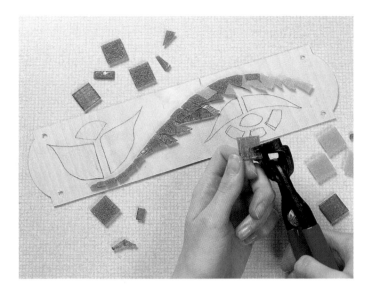

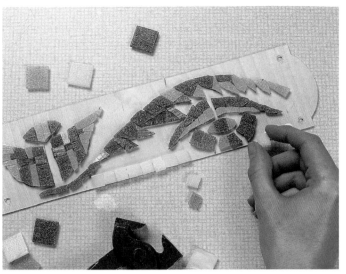

1 Transfer the design onto the skim ply as described on page 74. Cut out the fingerplate using the jeweller's saw for the curves; on the straight sides you will be able to manage with a craft knife and metal ruler. In each corner, drill a small hole 3 mm (⅛ in) diameter to accommodate the screws. Mosaic the main leaf, trying to get a smooth, clean, flowing line for the leading edge. Continue to mosaic the remaining green areas.

2 When you have finished the floral motif, lay a line of the soft background pink tesserae right the way along the edge of the fingerplate.

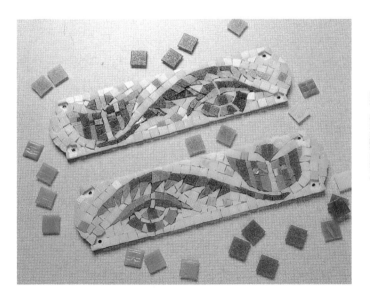

3 Fill in the background. Pepper the soft pink with the occasional mauve tessera to add a little texture. Once you have finished, leave the mosaic to dry for at least three hours, or until the glue becomes clear.

4 Then grout in the normal way (see pages 16-17). Allow to dry for at least two days before cleaning off the surface scum with the liquid floor cleaner and abrasive pad. When completed, screw or glue the fingerplate to a door.

SIMPLE MIRROR

An easy project for beginners, this mirror will liven up any bathroom. It also provides worthwhile practice at cutting and laying mosaic tesserae. You can either mosaic around the mirror or fit it in at the end when you grout the finished piece, as shown here.

The blue, green and white tiles which have been chosen here will harmonize with almost any bathroom decor, but do not feel that you have to stick to this colour scheme. Simply choose a range of colours that will match your own bathroom.

DESIGNER AND MAKER: SYLVIA BELL
42.5 CM (16½ IN) SQUARE

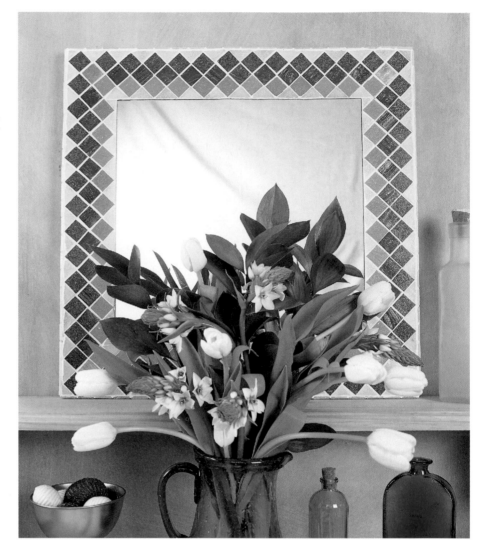

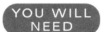

YOU WILL NEED

Pencil

Ruler

15 mm (⅝ in) thick MDF board measuring 42.5 cm (16½ in) square

Vitreous glass and gold-leafed tiles as shown right

Mosaic nippers

Safety spectacles

Large tweezers

Clear PVA wood adhesive

White grout

Trowel

Bowl of water

Rubber gloves

Grout spreader

Household cleanser

Cloths

Abrasive sponge

Pair of 'D' rings or mirror plates and screws

1	dark green (52 tiles)
2	white (143 tiles)
3	pale blue (44 tiles)
4	gold-leafed (4 tiles)
5	copper-veined dark blue (44 tiles)

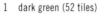

1 Draw diagonals from corner to corner across the board to find the centre and mark out the area where the mirror will fit. Place the board on a sheet of scrap paper or newspaper and organize your tiles. Cut triangular tesserae from the white vitreous glass. Run a bead of glue along one side of the board and mosaic the edge with uncut white tiles. Continue around the four edges of the board.

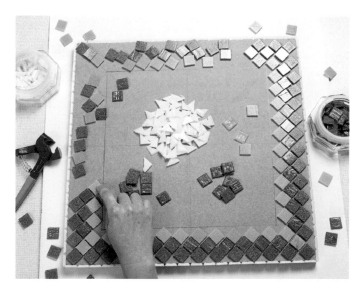

2 Starting with the corners, lay out the border tiles on top of the board, keeping to a strictly geometric pattern and making sure the gold-leafed tiles are correctly placed at the corners.

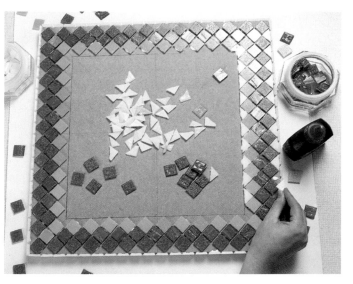

3 First glue down the coloured tiles, buttering the back of each one carefully and placing it symmetrically in position. Work your way around the frame, mosaicing the whole tiles. Then begin filling in the outer and inner borders with the white triangular tesserae.

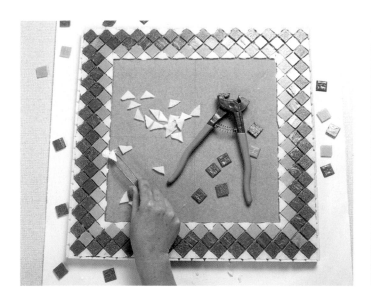

4 Continue filling in the borders until the design is complete. You may like to use large tweezers to tweak the tesserae gently into position along the inner border.

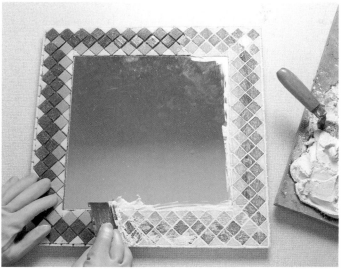

5 Use wood glue to fix the mirror in the centre of the design. When set (up to three hours), mix up the grout and water and carefully grout the mosaic area and between the mirror and the mosaic, taking extra care around the edges. Leave to dry for two days and then clean off and polish the mosaic using the household cleaner and water. Fix 'D' rings or mirror plates to the back of the board and hang on your bathroom wall.

SHELL DOOR NUMBER

I think that shell mosaics can look very tacky if the whole area is encrusted with tiny sea molluscs, all vying for attention. My solution here is to minimize the use of the shells, creating a hard sand bed for them to sit in. Sand is mixed with PVA, and as the PVA goes clear when dry, the end result looks like sand alone. Sharp sand has a beautiful, soft white colour. It is important that you do not use sand taken straight from the beach, as the salt content is corrosive which affects the finished mosaic.

At first glance, the procedure opposite looks complicated but, in fact, this is the quickest and easiest project in the book. Once you have assembled your materials, it should be possible to make the whole piece in half a day. If your house number runs into three digits, you may wish to make the plaque into an ellipse instead of the circle shown (see the variation shown opposite).

SIZE: 22 CM (8½ IN) DIAMETER
DESIGNER AND MAKER: MARTIN CHEEK
VARIATION: PAUL HAZELTON

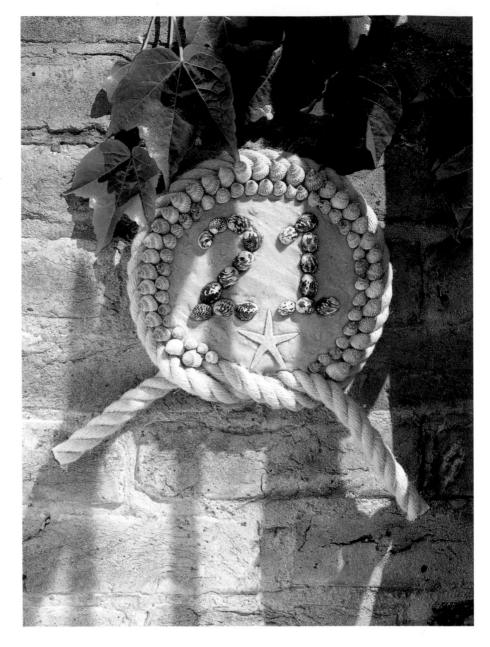

YOU WILL NEED

15 mm (⅝ in) thick MDF measuring 40 x 20 cm (16 x 8 in)	Cocktail stick
	Sheets of newspaper
Large compass or a plate 22 cm (9 in) diameter	Craft knife
	Two-part, slow-setting epoxy resin
Electric jigsaw	Small plastic mixing bowl
1 m (1 yd) of 20 mm (¾ in) thick yachtsman's rope (available from ship's chandlers)	Sharp sand
	One 'D' ring with screw
Pencil	Assortment of small sea shells as shown right
Two-part, fast-setting epoxy resin	33 large periwinkles
Piece of card measuring about 15 x 10 cm (6 x 4 in)	37 small periwinkles
	18 'bleeding teeth'
Lollipop stick or modelling tool	1 starfish

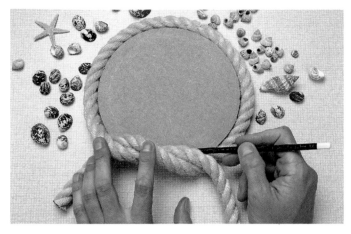

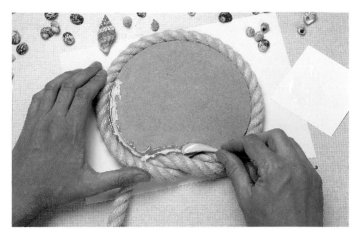

1 Draw a circle 22 cm (8½ in) diameter using a compass or a plate for a template. Cut this disc out with a jigsaw. Take the rope and run it around the outside edge of the disc and tie a half knot at the bottom of the disc, as shown. Draw around the two crescents made by the knot then untie and remove the rope and cut out these arcs. Replace the rope as before. It should now fit snugly around the MDF disc.

2 In a well-ventilated room, mix up the fast-setting epoxy resin by squirting out equal amounts onto the piece of card. Work on the reverse side of the rope and MDF disc (one side may look more pleasing than the other so choose that one as the top). Place it on a sheet of paper to protect your work surface and check that the two ends of the rope are sticking out equally from the disc. Then, using the modelling tool, run the epoxy resin into the gap between the disc and the rope. Leave to set (15 minutes).

VARIATION

Paul Hazelton's alternative design, below, shows how to adapt to an elliptical base. Paul has chosen to omit the rope and simply coat the edges of the MDF with sand and glue. Larger shells have been incorporated into the design to give a bigger, bolder finished effect.

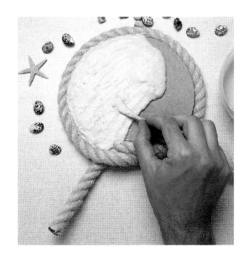

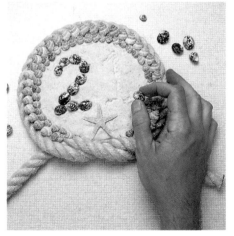

3 Remove the backing paper and, using a scalpel, cut off any hardened glue that has dribbled through the gap. Now mix up the slow-setting epoxy resin by squirting out equal amounts into the small mixing bowl. Mix together the two parts thoroughly and then slowly add the sharp sand. Spread an even layer of the sand and resin mix onto the board, trying to get it as even as possible.

4 Divide the periwinkles into two piles, large and small. Place a row of the larger periwinkles around the rim of the disc. It is best if you can be assertive in the positioning of the shells and place them firmly into the sand and resin bed and then leave them. However, if you need to, you can use the cocktail stick to finely tweak the shells into place.

Run a second row of smaller periwinkles inside the outer one. Then, with your modelling tool, mark out your house number (I live at Number 21) and carefully form the numbers with the 'bleeding teeth'. I have placed a starfish at the bottom to add a little colour. Finally, fix the 'D' ring to the back of the board and hang the mosaic on your front door or wall.

BEAD BOX

Beads have their own natural beauty and so I thought it best to not completely encrust the box with them, but rather to use them sparingly. However, this makes for a 'knobbly effect', so to compromise I incorporated ordinary vitreous mosaic tiles to meet them half way. The beads are very rich in colour so it is important that the vitreous should be limited. I have chosen only two colours: a dark blue and Sorrento blue which has a metallic veining running through it that echoes the stripes of the beads and sets them off.

Grouting would have been possible, but it seemed somehow inappropriate and would have added unnecessary weight to the box. Instead, we painted the box before gluing down any tesserae so that the areas between would look harmonious. The simple addition of some gold and silver wax gilt, dry brushed onto the surface, complements the sparkle of the beads.

SIZE: 9 X 9 X 9.5 CM (3½ X 3½ X 3¾ IN)
DESIGNER: MARTIN CHEEK MAKER: SYLVIA BELL

YOU WILL NEED

Mosaic nippers

Beads and vitreous glass tiles as shown right

MDF box 9 x 9 x 9.5 cm (3½ x 3½ x 3¾ in) (see Suppliers)

500 ml (1 pint) pot of white, quick-drying wood primer

Paintbrush

250 ml (9 fl oz) pot of sailor blue high gloss paint suitable for wood and metal (toy paint)

Jar of white spirit

Small pot each of gold and silver non-tarnishing wax gilt

Cloth

125 ml (4 fl oz) wood adhesive in a dispenser

Safety spectacles

Face mask

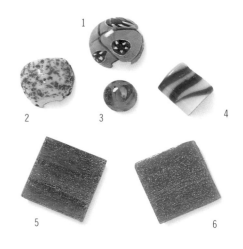

1-4 various beads
5 Sorrento blue (25 tiles)
6 dark blue (6 tiles)

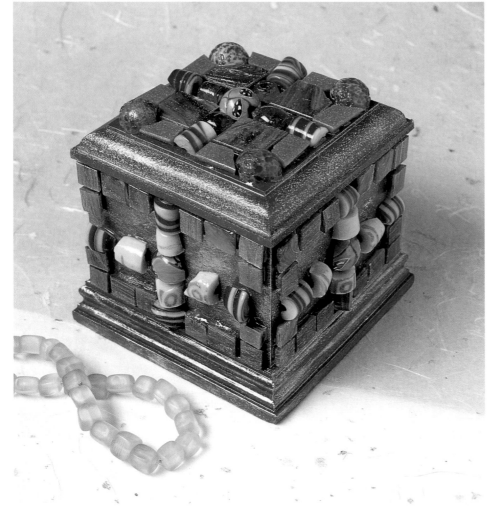

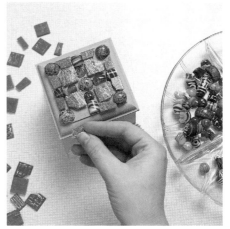

1 Using the mosaic nippers, break a few of the beads in half. If some shatter, keep the fragments, they too can be used. Play with the beads, arranging them on the lid of the box and use vitreous glass tesserae to help set them off. When you are happy with the result, place the beads and tesserae one by one to one side, keeping the pattern that you have made.

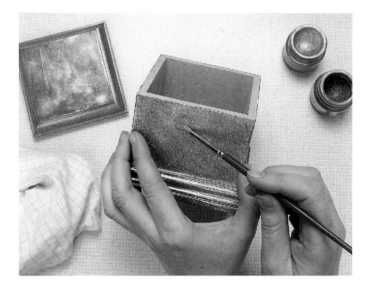

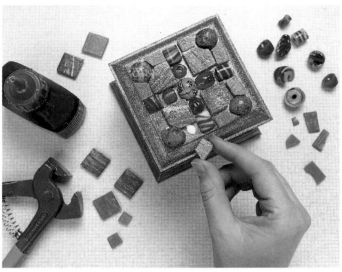

2 Coat the box with white primer and then leave to dry as instructed on the pot. As well as priming the wood, the white colour will give a greater luminosity to the top coat. If the white looks patchy when dry, give the box a second coat of primer and leave it to dry again.

Paint the box with a coat of the sailor blue paint and leave to dry as instructed. Once again, if the finished blue looks patchy when dry, and not very smooth, give the box a second coat and leave to dry. Finally, sparingly apply some of the gold and silver paints with a dry brush and then rub it into the top surface with the cloth until you feel satisfied with the effect.

3 Replace the beads and glass tesserae as before, but this time butter each piece with PVA as you position it.

It is important to use sufficient glue to hold the beads and tesserae, but be careful not to use too much or it will squidge out from underneath them and onto the painted areas between. Remember that the finished mosaic is not going to be grouted this time so any excess glue will show.

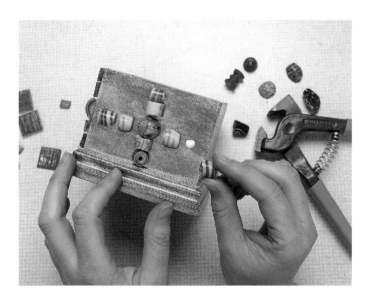

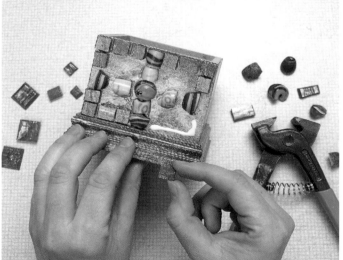

4 When you have finished the top of the box, put it to one side and start on the sides. Don't rush it. It is advisable to allow each side to dry thoroughly for an hour or so before turning the box round to mosaic the adjacent side.

5 In the areas where you know you are going to put glass tesserae, you can, if you wish, run a bead of glue onto the box. Continue in this way until you have mosaiced all four sides. Leave to dry for three hours. Fill the bead box with the remaining beads and replace the lid. Your bead box is now finished and ready to use.

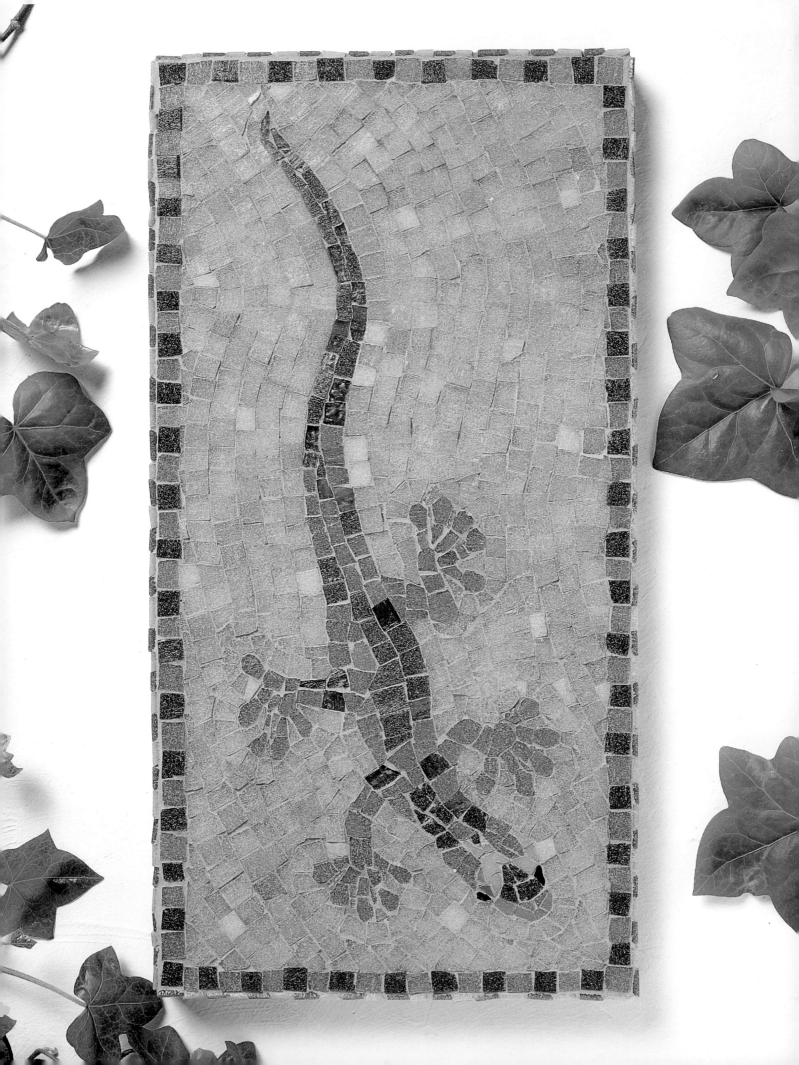

GECKO PLAQUE

In hot countries, it is believed that there is a gecko in every happy home and it is regarded as a symbol of good fortune. In Malaysia, for example, where 'chic chic' means 'good luck', it is nicknamed chee cha.

Because a lizard's scaly body looks a bit like a mosaic anyway, they are particularly suitable for this art form. The sensuous movement within their bodies is very appealing and a delight to try and capture. This modern mosaic is tipping a wink at the Romans, who also loved to include lizards in their mosaics.

DESIGNER: MARTIN CHEEK
MAKERS: ALAN WELCOME AND
MARTIN·CHEEK
SIZE: 40 X 20 CM (16 X 8 IN)

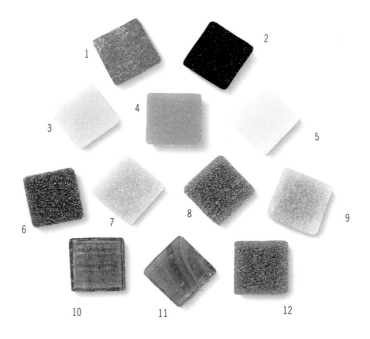

1	gold-leafed (2 tiles)	7	pale green (240 tiles)
2	black (3 tiles)	8	dark green (66 tiles)
3	pale blue (6 tiles)	9	mauve (36 tiles)
4	blue (4 tiles)	10	emerald vein (10 tiles)
5	pale green (98 tiles)	11	Sorrento blue (6 tiles)
6	purple (33 tiles)	12	lizard green (53 tiles)

YOU WILL NEED

15 mm (⅝ in) thick MDF measuring 40 x 20 cm (16 x 8 in)	Face mask
	Rubber gloves
Two sheets of A4 carbon paper	450 g (1 lb) of powdered grout
Template (page 76)	Bowl of water
Sharp pencil	Mixing board for the grout
Tracing paper	
Sheets of newspaper	Trowel
Vitreous glass tiles as shown above right	Plastic grout spreader
	Cleaning cloth
Mosaic nippers	Liquid floor cleaner
125 ml (4 fl oz) wood adhesive in a dispenser	Abrasive cleaning pad
	Pair of 'D' rings or mirror plates and screws
Craft knife	
Safety spectacles	

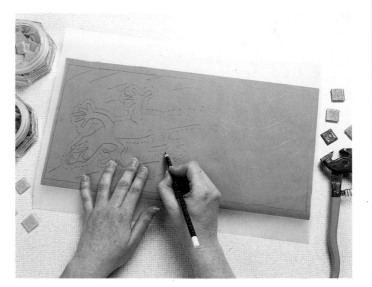

1 Using carbon paper laid ink-side down on the surface you are about to mosaic, transfer the gecko design and the background lines onto the MDF board as described on page 74.

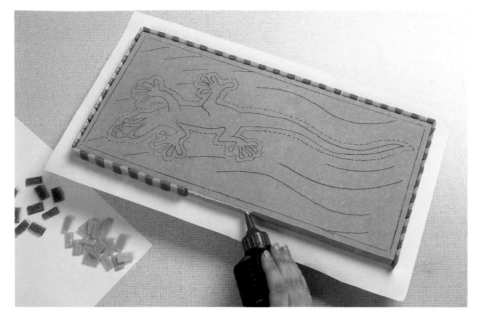

2 Begin by mosaicing the edge of the board. Place a sheet of paper under the board to protect your work surface. Cut some of the green and dark green tesserae in half and run a bead of glue along one side of the board. Fix the tesserae to the side of the board making sure that they adhere firmly. Continue on the other three sides and do not move the board as this may dislodge the tesserae and they may come away from the MDF. Leave to dry for about an hour.

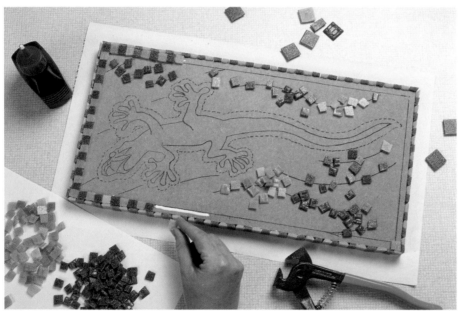

3 Now cut the mauve and purple tesserae for the border. The edge tesserae will be standing proud of the surface of the MDF board, but as you complete the mauve and purple border you will see that the tesserae around the edge become flush with it.

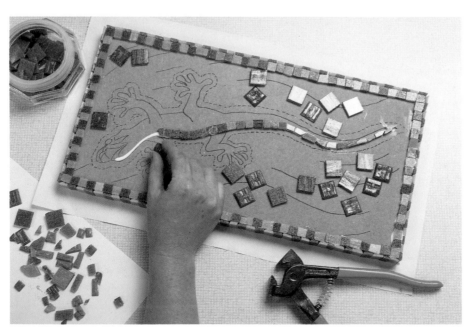

4 Cut the tesserae for the gecko, keeping each colour ready to one side on a separate sheet of paper. Start to mosaic the key line of the gecko's tail, back and neck by buttering the ribbed face of each tessera with glue and fixing it down on the board. Make a clear, flowing line as this will define the entire mosaic. It is rather like a jigsaw puzzle in that you need to select a tessera which fits well. Compare the angle made by the side of the tessera with the outline of the design and select the tile to match that angle. If you can't find a suitable tessera, then nibble one to fit.

5 Continue to mosaic the gecko. When you come to mosaic the toes, nibble a curve onto the tessera. Try to match the design as closely as possible but don't worry if it comes out slightly differently. When finished, cut up a pool of tesserae ready for the background and keep them on one side. Put in the line of background that surrounds the gecko, using the background colour. This *opus vermiculatum* is very important as it delineates the subject and separates it from the flow of the background. Then mosaic the rest of the background.

Once you have finished, leave the mosaic to dry for at least three hours; then tear off the newspaper and, using a craft knife, cut away any excess glue. Pour out the grout onto a board or into a bowl and add just enough water to make a fairly sloppy 'mud pie' mixture, mixing it thoroughly with the trowel. Put a small quantity in the middle of the plaque. Beginning with the sides, spread out the grout evenly, pushing it gently into the gaps.

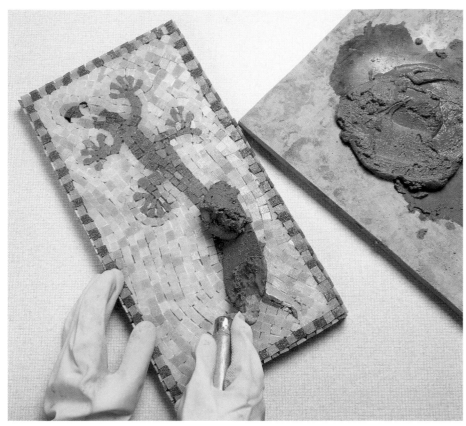

6 Next grout the top of the mosaic, running the grout in all directions to ensure that the gaps are thoroughly filled.

Wipe off with a damp cloth and, if necessary, remove all excess grout with a craft knife and make sure that no part of any tessera is submerged beneath the grout.

Allow to dry for at least two days before cleaning off the surface scum with the liquid floor cleaner and abrasive pad (see page 17).

Fix the 'D' rings or mirror plates to the back of the board and hang the mosaic as a picture.

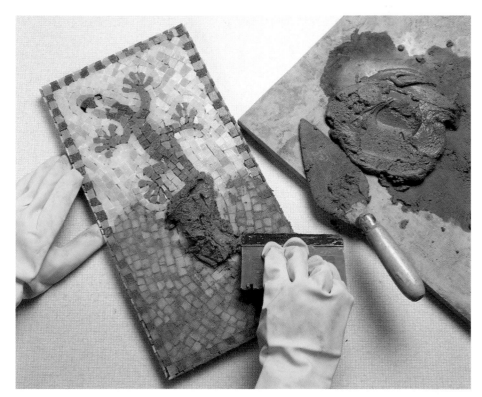

COCK CLOCK

*It seemed entirely appropriate to design
a clock based on a cockerel crowing
loudly at sunrise.*

*We have chosen a beautiful sunburst to go
behind the cockerel, so it is very important
that the cockerel doesn't get lost next to
such strong bright yellows. For this
reason, dark colours were used for the
body, and brilliant white for the head of
the cockerel, both of which have strong
tonal contrast against the yellow
background.*

*Re-assemble the clock by placing the
hands back on to the mechanism. To make
the hands stand out sufficiently from this
busy background, spray them with gold
spray paint before assembling.*

SIZE: 53 X 36 CM (21 X 14 IN)
DESIGNER AND MAKER: KIM WILLIAMS

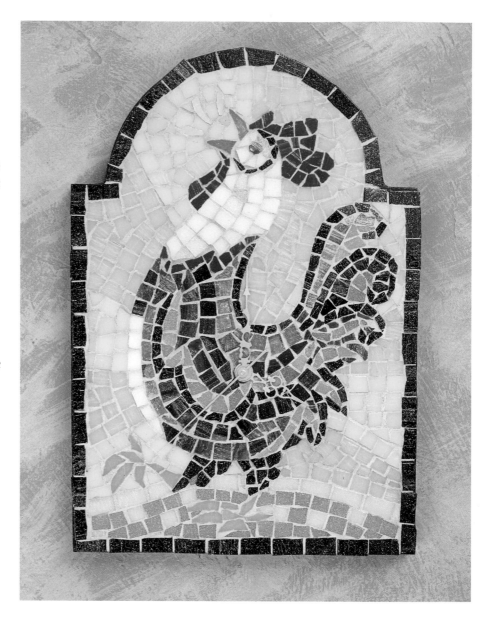

YOU WILL NEED

Wooden clock kit (see suppliers page 78)	Rubber gloves
Two sheets of A4 carbon paper	450 g (1 lb) of powdered grout
Template (page 74)	Bowl of water
Sharp pencil	Mixing board for the grout
Tracing paper	Trowel
Sheets of newspaper	Plastic grout spreader
Vitreous glass tiles as shown right	Cleaning cloth
Mosaic nippers	Liquid floor cleaner
125 ml (4 fl oz) wood adhesive in a dispenser	Abrasive cleaning pad
Craft knife	Black ink
Safety spectacles	Gold spray paint
Face mask	Pair of 'D' rings or mirror plates and screws

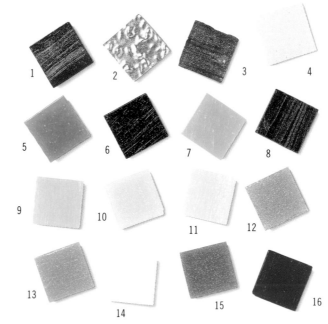

1	russet vein (3 tiles)
2	gold-leafed (2 tiles)
3	copper vein (15 tiles)
4	pale grey (3 tiles)
5	orange (3)
6	black (45 tiles)
7	tangerine (6 tiles)
8	bronze vein (12 tiles)
9	bright yellow (51 tiles)
10	lime green (6 tiles)
11	lemon yellow (36 tiles)
12	green (12 tiles)
13	pale blue (6 tiles)
14	white (12 tiles)
15	blue (8 tiles)
16	bright red (14 tiles)

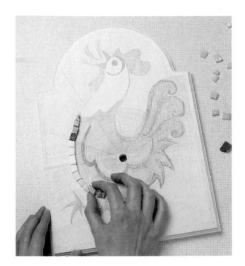

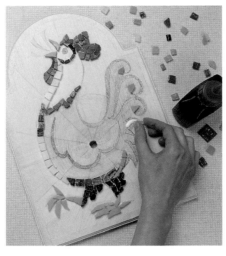

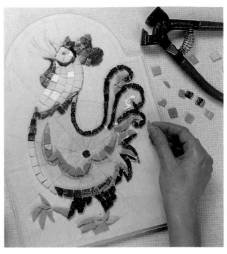

1 Transfer the design onto the face of the clock as described on page 74. Colour in the design as this will help you attain good colour contrast between the cockerel and the background. Begin by mosaicing the 'key line' from the cockerel's throat, down his breast to his feet. Try to get a good clean flowing line that will clearly define the cockerel from the bright yellow background.

2 Next, add the cockerel's comb and wattle in bright red, followed by his beak and legs in tangerine. Finally, set the blue tesserae that will form the inside feathering of his tail feathers.

3 Fill in the cockerel's face and head. Lay the black key lines that make up his tail feathers and the blue one that forms the base line of his wing.

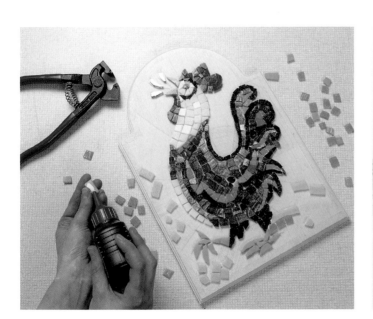

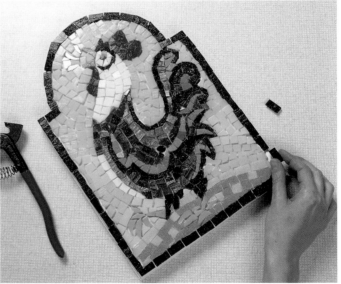

4 In making the eye (see page 13), we chose a tile of copper vein. You, too, *should* be able to find a similar tile to this. By carefully nibbling around this line, a tessera that looked like a closed eye was made. Continue in this way to fill in the body and tail of the cockerel.

Mosaic the hillock on which the bird is standing. Remember that things get lighter towards the horizon, so make the horizon line pale green.

5 Introduce more of the darker green tesserae as you add each successive row, to achieve a blended effect. Mosaic the sunburst in the two shades of yellow. Try to make the tesserae form lines that radiate out from the vanishing point, in this case, where the sun is. Finally, add the row of black tesserae to make the border, leave to set for three hours, then grout and clean in the normal way (see pages 16-17). When the mosaic is complete, use black ink to paint the fluted wooden edge of the clock, blending it in with the black border. Reassemble clock components.

WAVE
PICTURE FRAME

What better way to show off your favourite picture than to mosaic a frame to go around it? Remember that the strong mosaic colours make for a very rich effect which can overpower or even clash with your picture if it has a lively composition. So if your picture is a busy one, choose quieter, softer colours and vice versa.

Here I have chosen a classical Roman 'wave' border based on a traditional Roman design. It was often used to frame huge scenes with swirling fish of all weird and wonderful manner and description. I have used this border many times and have always found it tricky to divide each side into an exact number of waves. Like a lot of the geometric patterns used in Roman mosaics, the look is deceptively simple until you try to do it yourself.

SIZE: EXTERNAL DIMENSIONS
29 X 23 CM (11½ X 9 IN)
INTERNAL DIMENSIONS
19.5 X 13 CM (8 X 5 IN)
DESIGNER AND MAKER: MARTIN CHEEK

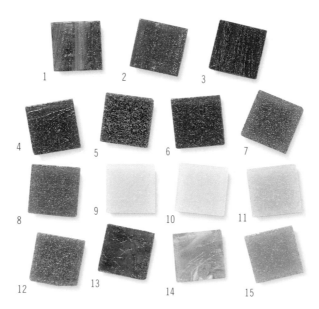

1 purple vein (6 tiles)
2 dark blue vein (50 tiles)
3 dark purple vein (27 tiles)
4 navy blue (18 tiles)
5 purple (4 tiles)
6 blue (40 tiles)
7 dark viridian (3 tiles)
8 cyan (16 tiles)
9 pale blue (50 tiles)
10 ice blue (7 tiles)
11 mid-pale blue (13 tiles)
12 grey blue (5 tiles)
13 Sorrento blue (5 tiles)
14 sea green vein (2 tiles)
15 blue (37 tiles)

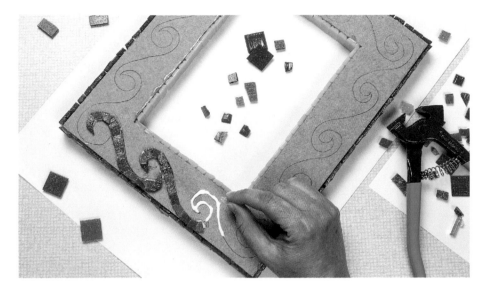

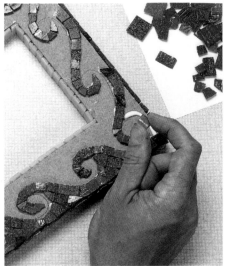

1 Mark the vertical centre line and cut the inner rectangle out of the MDF. To do this, drill a hole 1 cm (½ in) diameter to get the jigsaw blade through. Transfer the design onto the MDF board as described on page 74. Then mosaic the outer edge of the frame. Place a sheet of paper under the frame to protect your work surface. Cut the various shades of dark blue tesserae in half and run a bead of glue along one side of the frame. Fix the tesserae to the side of the board making sure that they adhere firmly.

Continue on the other three sides – do not move the board around as this will allow the tesserae to come away. Repeat this process for the inner frame using the various shades of light blue tesserae. Leave to dry for about an hour.

Run a bead of glue along the crest of each wave and mosaic down to where it touches the edge of the frame. Repeat with the next wave, then finish off the tail of the previous wave to where it meets the new wave. The reason for doing this is because the crest of the new wave is more important than the tail of the old wave, so mosaic that first.

2 When the inner and outer edges have dried, peel off the backing paper and discard. Cut off any excess glue with the craft knife. Continue to mosaic the waves as described in step 1 until you have gone all the way around the frame. Fill in the triangular areas under the waves – try to echo the flow of each wave as you do so.

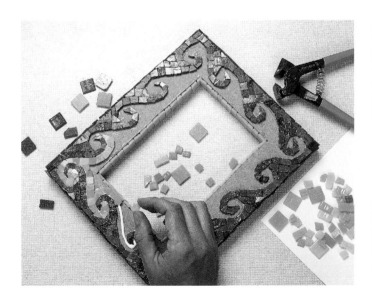

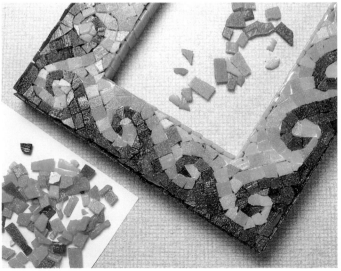

3 Now mosaic the sky. Once again, start at the crest of a wave and run a bead of glue along the side of it. Mosaic this line, finishing off underneath each crest in a circular movement (see page 15).

4 Continue all the way around the frame. Fill in the triangular areas above these sky lines, echoing the flow as you do so. Leave to dry for three hours and then grout and clean as described on pages 16-17. Fix the 'D' rings or mirror plates to the back of the frame, glue your picture in place and hang the mosaic.

CIRCUS PODIUM POT

This simple but attractive pot clearly demonstrates how even the simplest everyday item can be transformed by using mosaic. The shape reminded me of a circus podium – hence the design. However, we chose vivid greens and blues as opposed to circus colours (ie reds and oranges) to echo the natural colours of the plant which it will contain. Dark viridian was chosen for the top and bottom bands so that the design would be 'contained'.

OVERALL DIMENSIONS:
14 X 12 CM (5½ X 4¾ IN)
DESIGNER: MARTIN CHEEK
MAKER: SYLVIA BELL

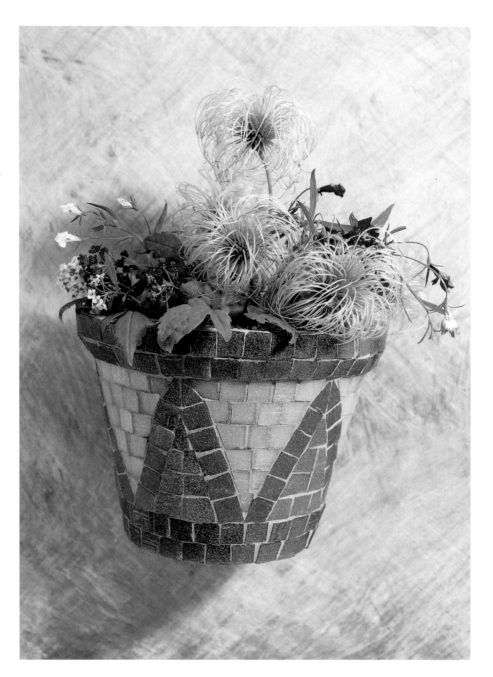

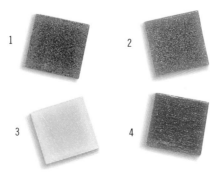

1 dark viridian (43 tiles)

2 mid-green (12 tiles)

3 lime green (23 tiles)

4 cyan (15 tiles)

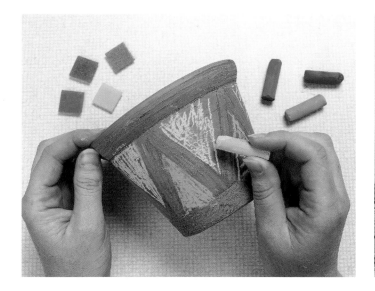

1 Draw the design on the pot using the coloured pastels or chalks. Drawing onto a three-dimensional object is always quite different from a flat piece of paper. You may find that you have to space out the design further than you think.

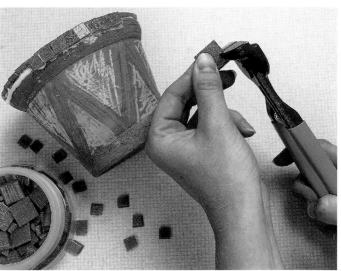

2 Begin by mosaicing the top rim of the pot with dark viridian tesserae. Leave to dry for an hour or so and then mosaic the top and bottom bands, also in the dark viridian. This may well take time and patience. Our pot, being so small, proved to be a bit tricky. When we turned it round, gravity did its worst and some tesserae dropped off. The obvious, though frustrating, solution is to work in stages, allowing the glue to 'take' for about 30 minutes each time before you turn it.

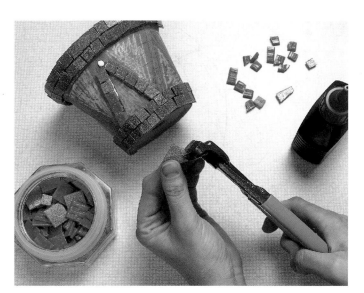

3 Mosaic the cyan zigzag. The *opus* is diagonal here, so you need to nibble the end tesserae to the correct angle

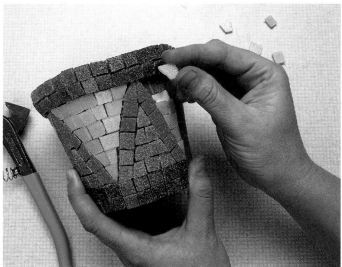

4 Fill in the remaining triangles alternating the mid- and lime greens. Mosaic in horizontal rows, nibbling triangles where necessary to fit. When finished, leave to set for three hours and grout and clean as described on pages 16-17. Fill the pot with a suitable plant and hang it on a wall in the sun.

PEBBLE MOSAIC PAVING SLAB

Simple designs work best for pebble mosaics. One of the difficulties is getting the pebbles to sit close enough to each other to get the detail you require. For this reason I have chosen the broad curves of a Greek knot commonly used in Roman mosaics. It also has the advantage of being a repeat pattern, so that if you wish, you can mosaic as many as you wish and line them up to form an attractive border to your garden.

We used a large bag of Arran pebbles from Scotland, bought from a builder's merchants. If you live near the coast, it is, of course, possible to use pebbles off the beach, but you should ask permission from the local authorities first.

Pebble mosaics look their best when wet. You will soon find yourself looking forward to a downpour so that you can go out into the garden to admire your work!

Once again, this looks, at first glance, to be a very complicated project. In fact, we were able to complete it to the stage of pouring the concrete in just one day. One of the thrilling aspects of this type of mosaic is that you are never quite certain how the finished piece will look. We had to be patient for a whole week before turning out the mould to find out. The temptation to cheat is always great, but once you have and if, like me, damaged days of work, you soon learn to be patient and let chemistry do its work.

SIZE: 66 X 48 CM (26 X 19 IN)
DESIGNER: MARTIN CHEEK
MAKERS: ALAN WELCOME AND
MARTIN CHEEK

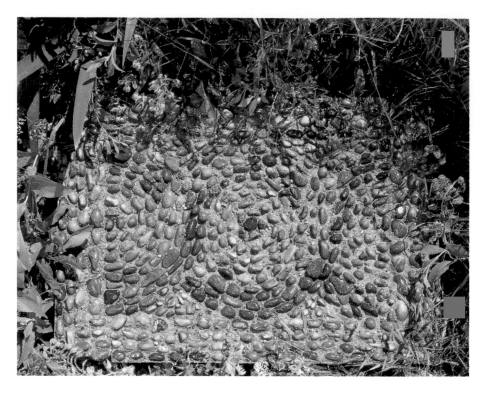

YOU WILL NEED			
Piece of brown craft paper measuring 76 x 56 cm (30 x 22 in)	Two 2.5 m (8 ft) lengths of 10 x 2.5 cm (4 x 1 in) timber	25 kg (50 lb) bag of sharp sand	Cocktail stick
	PVA wood adhesive	Wooden levelling tool (see page 8)	Plant water atomizer
MDF board measuring 80 x 60 cm (31½ x 23½ in), waxed (see pages 15-16)	Dril!	Builder's float (see page 8)	25 kg (50 lb) bag of cement
	2.5 mm (1/16 in) drill bit		Metal bucket
	Four 5 cm (2 in) no. 8 screws	Paper	One 1 m (3 ft) square board
Roll of 5 cm (2 in) wide gummed brown paper tape	Screwdriver	Pencil	Shovel
	Tub of petroleum jelly (vaseline)	12 kg (24 lb) bag of pebbles varying in size and colour as shown below	Rubber gloves
Template (page 77)			Trowel
	500 ml (1 pint) white spirit	Large pair of scissors	Scrubbing brush

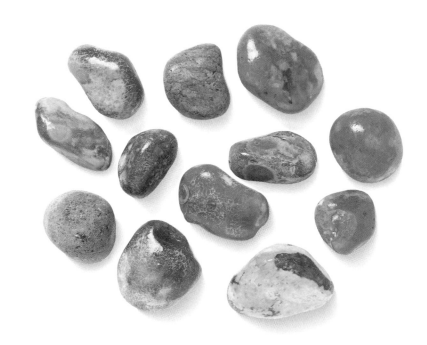

MAKING A SIMPLE MOULD

Making a mould and laying the pebbles indirect (upside down) into a shallow bed of sand ensures that the final surface of the slab will be flat and therefore easier to walk on.

Stretch some brown craft paper onto the waxed MDF board and secure with 5 cm (2 in) wide gummed brown paper tape. Leave it to dry (see page 16). Cut the 2.5 m (8 ft) length of 10 x 2.5 cm (4 x 1 in) timber into two lengths of 76 cm (30 in) and two lengths of 56 cm (22 in). Run a bead of glue down the end of each batten where it touches the adjoining piece of wood and glue down the batten onto the area where the brown tape overlaps the brown paper on the board. Screw the adjoining walls together with the 5 cm (2 in) long screws. Run more glue generously along the base of the batten where they touch the board and rub it into the joins with your index finger.

When the glue has set (up to an hour), paint the inside walls with the release agent made from a 50:50 mixture of petroleum jelly and white spirit. You have now made a simple mould. Because the paper is temporarily fixed to the board, the whole mould is easy to dismantle and will fall apart easily when necessary.

Pour sharp sand into the mould to form a bed 12 mm (½ in) deep. The final depth from the top of the pebble to the top of the cement is called the rebate and this is determined by the depth of the sand you initially pour into the mould. Obviously, as you push the pebbles into the sand, so the sand is forced up between the pebbles. Thus the rebate on your mosaic will be about 2 cm (¾ in) deep, depending on the size of the pebbles.

Take the levelling tool (see page 8 for making) and sit it on the adjacent sides of the mould. By running the tool across the top of the mould you can level out the bed of sand.

1 Use the builder's float to make the sand compact and flatten out any rough areas in the top surface of the sand. Then draw the design on page 77 to size on paper. Carefully cut out the shaded areas: the middle circle, the two semi-circles on either side and the four circular triangles between the rings and the border. Keep the smaller cut-out pieces and place on one side and place the larger cut-out piece of paper into the mould. Trace down the design onto the sand using a scalpel, a sawing action will ensure that the surface of the sand stays undisturbed.

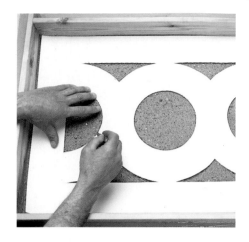

2 The smaller cut-out pieces can be used to tidy up the scalpel lines once the main cut-out piece of paper has been removed. Use the sharp edge of the builder's metal float to cut the straight edge lines into the sand.

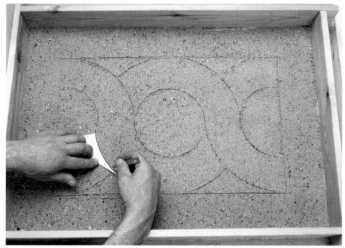

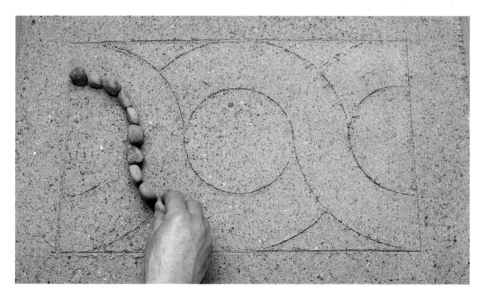

3 Sort out the pebbles into piles of their various colours: here blacks, greys and browns. Within each pile, separate the larger pebbles from the smaller ones. Using the larger black pebbles, lay the key line that describes the outer edge of the knot. Be positive in your choice and in the placing of the pebbles into the sand. Try to avoid repositioning as this disturbs the sand and results in the pebbles being not so well supported. It helps if the sand is kept moist; use a plant water atomiser and occasionally give the surface of the sand a quick spray. If you do disturb the surface of the sand, use the trowel to repair the damage, sprinkling in a little more sand if necessary. Push the pebbles into the sand until they are touching the brown craft paper. Remember that the surface of the paper will eventually become the top surface of your pebble mosaic.

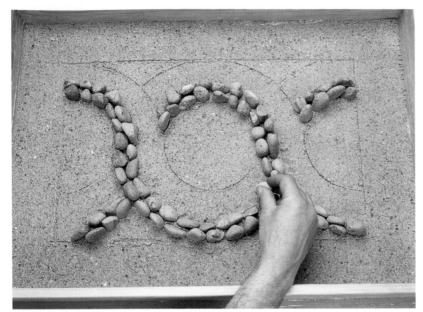

4 Lay a second line of pebbles alongside the key line. Try to choose pebbles that fit snugly between where the first row of pebbles touch. Pack the pebbles as tightly as you can. You will find that the process of inserting the pebbles gets progressively easier as they begin to prop each other up. You can check that the depth of the sand is consistent by using a cocktail stick as a simple depth gauge. You will find that you can work surprisingly quickly, covering a large surface area in a relatively short space of time.

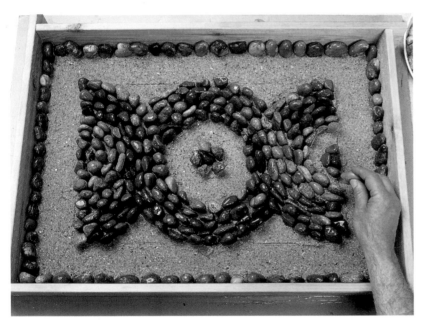

5 Continue mosaicing the knot. Try to blend in grey pebbles with the black ones so that you achieve some shading. This is especially important where the curves cross over and under each other. Wetting the mosaic will make it easier for you to judge the subtle differences in the shade of the pebbles. Mosaic in the dark centres with black pebbles and, working inwards, fill in the remaining loop with brown pebbles. Mosaic the outside edge with dark pebbles.

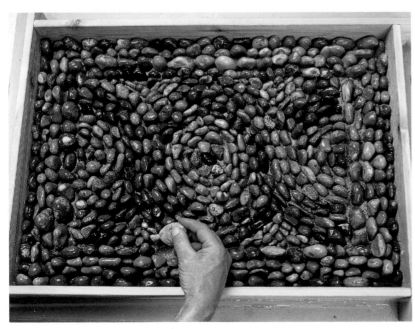

6 Continue to mosaic the border. We managed to get two rows of brown and one row of dark grey before touching the knot. Fill in any gaps with thin pebbles of the same colour. Then complete the mosaic by filling in the small triangular areas with brown pebbles.

7 Mix a 1 litre (1¾ pints) solution of cement and water only, to the consistency of thick cream. Pour slowly and evenly over the pebbles. This is to fill any small gaps that the sand and cement would be too thick to flow into. Leave the cement solution to dry to the consistency of putty. (About an hour or so depending upon the temperature.) This will also help to hold the pebbles in place when the heavy sand and cement mixture is poured on top of them.

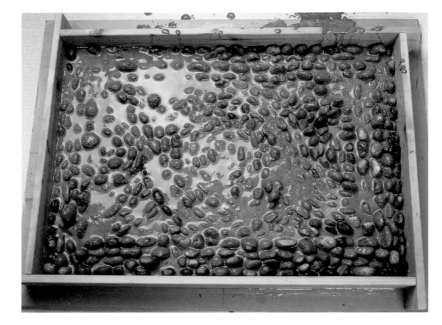

8 Thoroughly mix together the sand and cement 3:1 at the dry stage before adding any water. Make a volcano and slowly add the water, mixing thoroughly with a shovel. The final sand and cement mixture should have the consistency of a thick mud pie. Carefully add the sand and cement in small quantities to the mould using a trowel so as not to disturb the pebbles. Level out the surface with the trowel. Leave to harden. The concrete will take about three weeks to fully harden. After a week it is set hard enough for you to unscrew the walls of the mould and knock them away from the slab with a hammer.

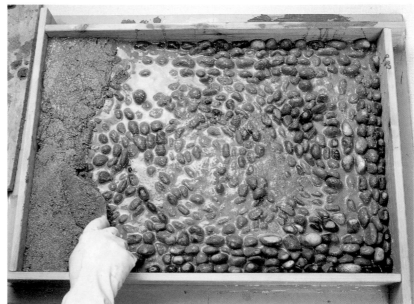

9 With a strong friend to help you, carefully turn the slab over onto its back. Remove the wooden board – this should come away easily because it was waxed – and brush away the sand. This is the most exciting part as it is a bit like archaeology as you brush away the sand to reveal what lies beneath the surface.

Finally, wash and scrub the mosaic with a scrubbing brush. If the cement has 'seeped' through onto any of the pebbles, you could scrape off the offending cement with a chisel. However, don't worry too much about this, once *in situ,* the overall effect will be wonderful – especially when it rains!

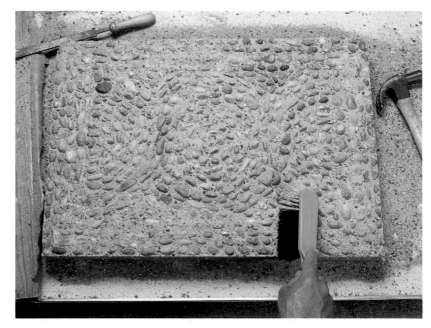

ROMAN PAVING SLAB

This geometric paving slab is based on an ancient design. The Romans loved interlacing patterns, and this one can often be seen as part of a border or elsewhere on a large Roman mosaic floor.

This mosaic is made indirect, in other words laid in reverse and fixed onto paper with a water-soluble glue. By using a simple wooden mould to contain the sand and cement, a paving slab can be made. The sand and cement, once hardened (this takes at least a week), is ideal for any patio or garden.

SIZE 46 CM (18 IN) SQUARE
DESIGN: MARTIN CHEEK BASED ON A TRADITIONAL ROMAN DESIGN
MAKERS: ALAN WELCOME AND MARTIN CHEEK

YOU WILL NEED

Brown parcel paper

Roll of gummed brown tape

MDF board measuring 80 x 60 cm (31 x 24 in), waxed (see pages 15-16)

Tracing paper

Pencil

Carbon paper

Template (page 76)

Colouring pencils

Cinca ceramic tiles as shown opposite

safety spectacles

Wallpaper paste

No. 8 paintbrush

PVA wood adhesive

One 2.5 m (8 ft) length of 5 x 2.5 cm (2 x 1 in) timber

Cupful vaseline and white spirit mixed together in equal parts

12 mm (½ in) paintbrush

Four 5 cm (2 in) no. 8 screws

Drill

2.5 mm (1/16 in) drill bit

Screwdriver

Toothbrush

Cup full of fine silver sand

Trowel

Chicken wire

Wire cutters

Rubber gloves

Building sand and cement

Hammer

Grey grout

Squeegee

Cloths and sponges

Bowl of water

Liquid floor cleaner

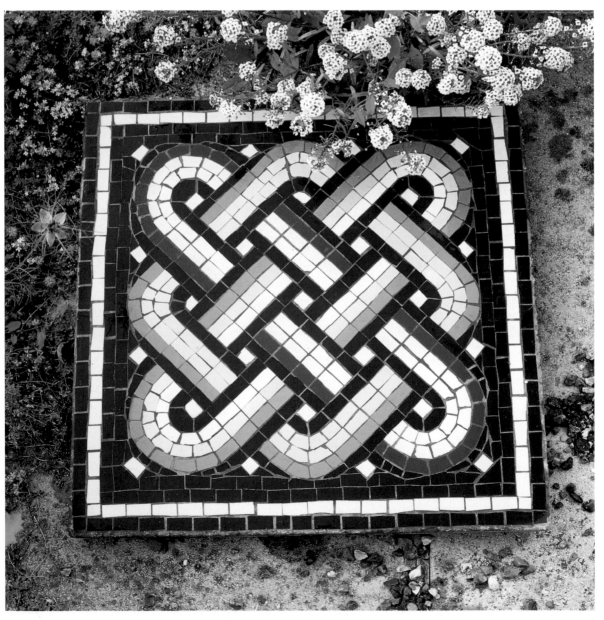

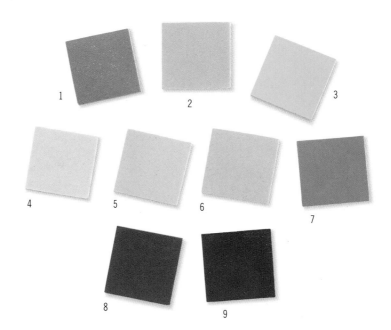

1 dark grey (24 tiles)
2 pale grey (23 tiles)
3 dark yellow (24 tiles)
4 pearl (95 tiles)
5 rose (23 tiles)
6 pale yellow (21 tiles)
7 gold (75 tiles)
8 brown (24 tiles)
9 black (273 tiles)

1 Stretch some brown parcel paper onto a waxed MDF board (see pages 15-16). Draw the design to size on tracing paper. The design is symmetrical about two axis, so you only need to trace a quarter of the full design. Transfer the design to the paper as described on page 74. By drawing a horizontal and vertical line through the centre, the design can be traced down onto the paper in four stages, turning the tracing through 90 degrees at each stage. Then colour in the design using colouring pencils as close in colour as you can get to the Cinca tiles. This may seem unnecessary, but it allows you to concentrate on the mosaicing without having to constantly worry about whether you are using the right colour.

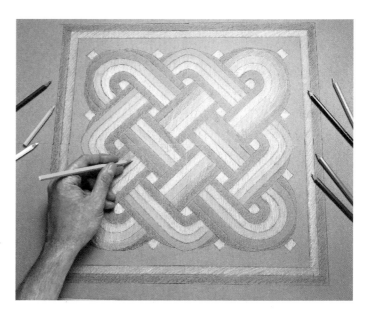

2 Begin by gluing down a pearl tessera in the middle of the design. Remember that the finished surface of the mosaic will be the one that touches the paper. Cinca tiles don't have a right and wrong side so you can flip them over if you wish. Add the four black lines that spin off this central tessera. Place down complete half tiles where you can; where this is not possible, cut down one tessera and place it in the middle of the line, where it will not be so obvious. Leave a small gap of 1 mm (1/16 in) between each tessera. When grouted, these gaps will delineate the tesserae and emphasize the geometric quality of the design.

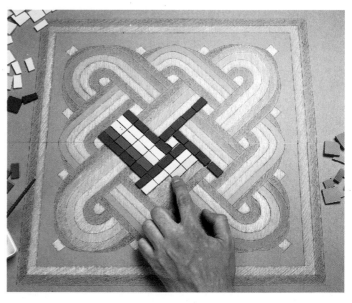

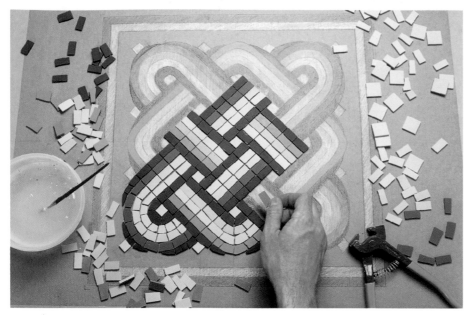

3 Working outwards, mosaic the four central rectangles. Look at where the bands overlap and aim your mosaic line so that it lines up with where it reappears. This is easier said than done! It is helpful to use a ruler to make sure that you are still on line when you come out on the other side. If the lines are wobbly here the final effect won't be as good, so it is worth taking care and spending time to get the lines neat.

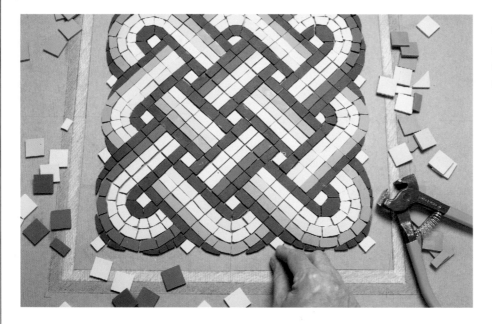

4 Put in the next eight pearl tesserae. If you have worked neatly so far, these will line up, forming a neat grid. Working outwards, continue to mosaic the knot until it is completed.

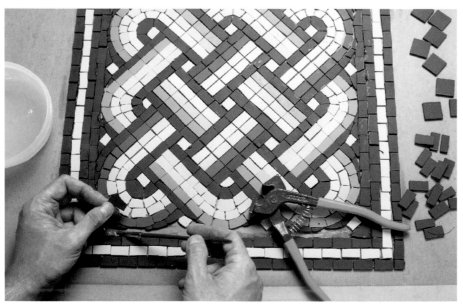

5 Finish off 'papering' the mosaic by laying down the black and pearl border and the surrounding black background area. When you have finished the mosaic, make a mould around it to contain the concrete (see page 49). Prepare the surface with a releasing agent, (also as on page 49).

6 Sprinkle a small amount of fine silver sand onto the top surface of the mosaic and carefully brush into the interstices. The sand acts as a barrier and prevents the concrete from flowing under the tesserae onto the surface of the mosaic. Make sure that there is no sand left on the top surface of the mosaic as this will prevent the cement from keying.

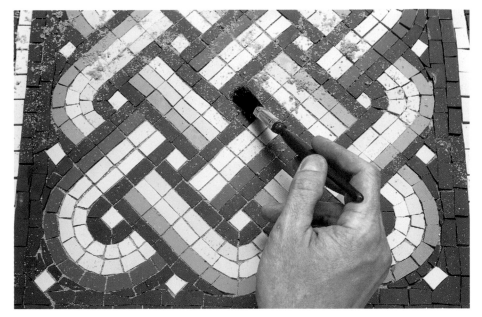

7 Cut a piece of chicken wire to the same size as the slab. Place it in the mould to make sure it fits snugly. Any extra wire can be bent over and squashed down. When you are satisfied, remove the wire from the mould. Then mix the sand and cement in their dry state. Make a well in the mixture and gradually add the water until the sand and cement are well mixed and of thick mud pie consistency. Slowly, pour this into the mould and when you have covered the surface of the mosaic, add the chicken wire. Top up the mould with the remaining sand and cement.

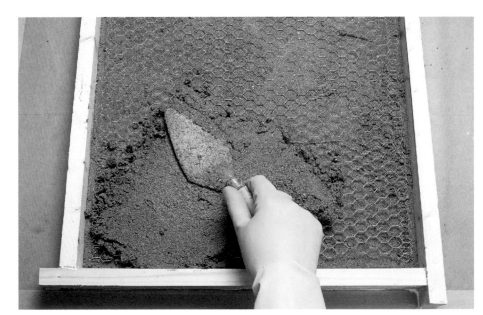

8 Leave to harden for at least a week, then unscrew and remove the wooden battens by gently tapping them away with a hammer. Because they are only glued to the brown craft paper they will come away quite easily. Turn the slab over and remove the MDF board.

Soak off the paper (if the board has been properly waxed, the paper should peel away very easily), and using a toothbrush sweep away any excess sand that is still lying in the interstices. Grout and clean as described on pages 16-17.

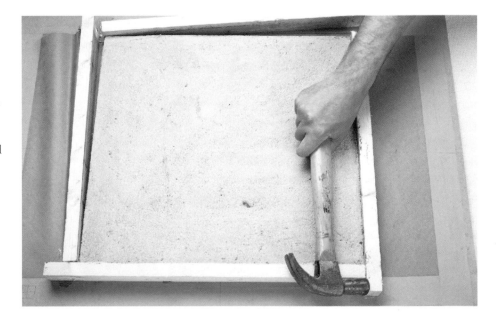

SUNDIAL

Smalti are beautiful, both to work with and to look at. The rippled surface of this hand-made glass catches and plays with the light that falls on it, so what better thing to make with it than a sundial? I wanted to show how even when used very simply, it still enlivens and enhances the piece. The octagonal shape of the slab suggested that all I needed to do was to radiate alternating bands of orange and yellow smalti around the top surface of the dial and over the sides to create a jolly sunburst effect.

OVERALL DIMENSIONS: 40 X 40 X 8 CM (16 X 16 X 3½ IN)
DESIGNER AND MAKER: MARTIN CHEEK

1	yellow tesserae 1.5 kg (3 lb)
2	orange tesserae 1.5 kg (3 lb)

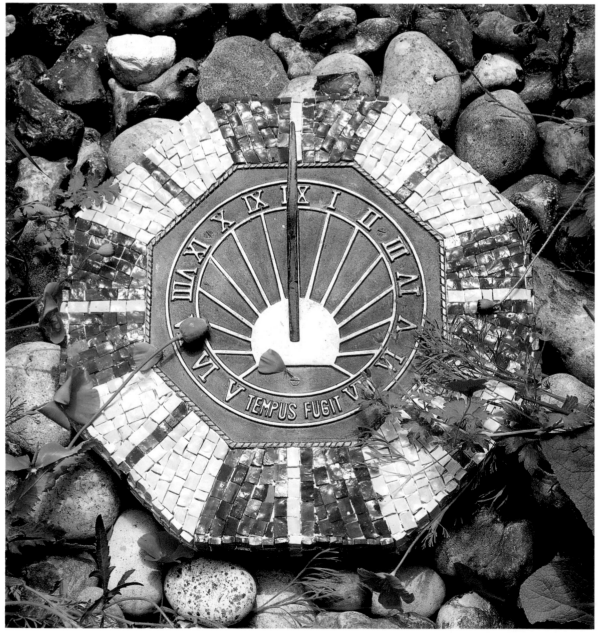

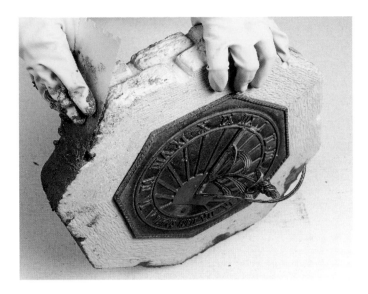

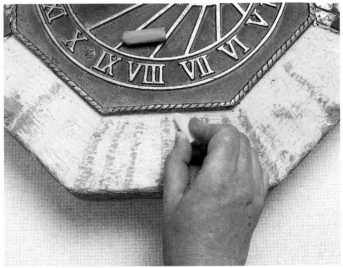

1 The base of the sundial I bought was cast concrete which had brickwork effect indentations on the side. To create flat sides, I filled these groves with a rapid set floor and wall tile adhesive. Use a grout spreader to achieve a smooth flat surface and leave to set.

2 Using pastels or chalks, divide the octagonal top surface into its eight segments. Colour each segment in orange and yellow alternately. To break this up I made the central line of each segment the opposite colour, ie a yellow strip through the centre of each orange band, and vice versa.

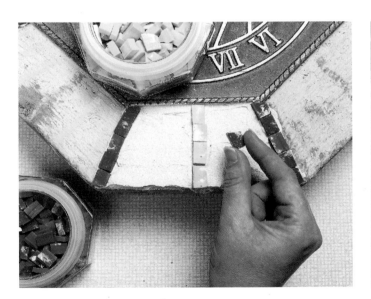

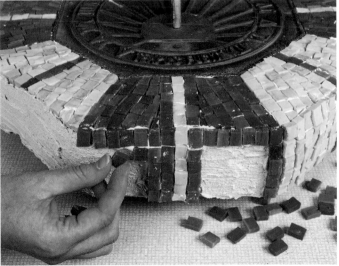

3 Mix the waterproof tile adhesive with water to the consistency of smooth porridge. Begin mosaicing by applying an even layer of the adhesive to a segment with the metal modelling tool or a lollipop stick. Lay the two diagonal outer lines and the vertical central line of smalti first. The lines on either side of the central line are also vertical, mosaic these next. If a piece of smalti does not fit exactly, trim down the last piece to size; it looks better if this smaller piece is in the middle of the line and not at either end. Now work from the diagonals inwards to meet the central lines. Nibble the angle of the two end tesserae of each diagonal line to the same angle as the sundial.

4 Continue in this way, alternating the colours on each successive segment until you have completed the top surface of the sundial. Then mosaic the sides by running vertical lines of smalti down the edge of each segment. Try to match the vertical lines to those on the top surface of the sundial.

Continue on each successive side until the sundial is completely covered in smalti. Leave to harden for 24 hours, then place the sundial in the middle of your favourite flower bed, where it can catch the sun.

BROKEN CHINA TERRACOTTA POT

Even the simplest shapes can be useful to the mosaic artist. By using china, which has a very intricate design, you can get away with using quite large tesserae as the pieces are intrinsically interesting. Indeed, if the pieces are too small, you can't appreciate the delicacy of the patterns or the subtle shading of the colours within the china itself.

You do not need to grout the finished mosaic since the adhesive is forced up between the pieces of crockery and so 'self grouts' as you work.

Once again, this is a project that looks complicated, but isn't. We completed the entire mosaic in a morning. Before attempting a larger, more complicated structure using broken ceramic, as, for example, the bird bath on pages 70-3, it would be a good idea to have a go at a small pot with a simple shape like this one.

Having finished this pot, we thought that the white adhesive looked a bit stark and did not set off the pieces of crockery. To remedy this, I stained the adhesive with a waterproof blue ink. It did the trick. It would, of course, have been better to colour the adhesive at the dry stage with powder paint!

OVERALL DIMENSIONS: BACK SEMI-CIRCLE:
21 X 16 CM (8 X 6½ IN)
DISTANCE FROM FRONT TO THE BACK OF THE
POT: 13.5 CM (5 IN)
DESIGNER AND MAKER: SYLVIA BELL

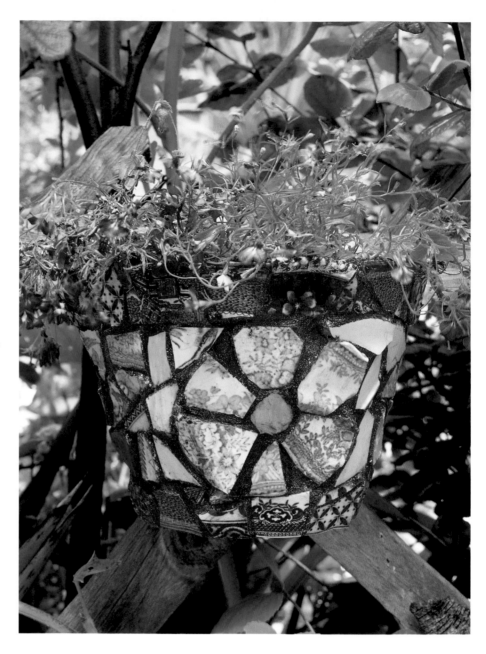

YOU WILL NEED

Assortment of broken plates and china as shown right
Plastic bag
Hammer
Mosaic nippers
5 kg (11 lb) rapid set floor and wall tile adhesive
Bowl
Trowel
Rubber gloves
Cleaning cloth
Liquid floor cleaner
Abrasive cleaning pad
Waterproof blue ink

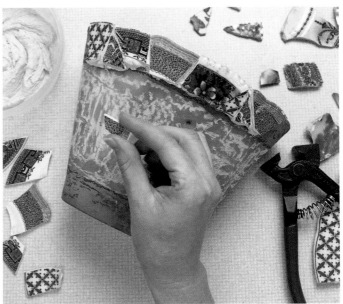

1 Roughly break up the plates by putting them in a plastic bag and hitting it with a hammer. Then use the tile nippers to break up the pieces still further. Sort out the darker, stronger colours in one pile and the more delicately shaded ones in another. Mix up the rapid set floor and wall tile adhesive with water until it is the consistency of porridge.

2 Begin by mosaicing the stronger blue bands at the top and bottom of the pot. As you break up the plates, you will notice that some pieces have cut sides and others, the ones taken from the edge of the plates, have a rounded side. It looks neater and gives a better finish if you can place the uncut, rounded edge along the top and bottom of the pot.

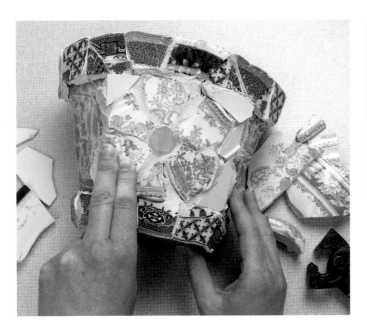

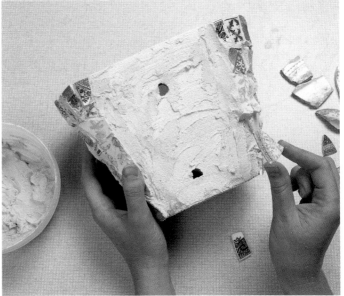

3 Mosaic in the flower. Place the centre first and then add the petals around it.

4 Continue mosaicing this remaining centre band until the entire surface is covered, apart from the flat area at the back of the pot where it rests against the wall.

FROG SPLASHBACK

This design is derived from a series of frogs that Sylvia and I made for a swimming pool. Sylvia liked him and thought he would make a good splashback. This project was made indirect so that the final mosaic surface would be flat and easy to clean. The finished surface of the mosaic is the one that touches the paper, so remember to lay the tesserae flat-side-down. This is very important when making an indirect mosaic using vitreous glass, which has a 'right' and a 'wrong' side.

Make sure that the pale underbelly of the frog stands out well enough from the background. We have chosen a white background to ensure this, but you may prefer to use various blues to create a watery-effect. If so, make sure that you use a dark blue tile against his light green underbelly and a light blue tile against his dark green back when placing the opus vermiculatum to achieve significant contrast.

SIZE: 53 X 36 CM (21 X 14 INCHES)
DESIGNER: MARTIN CHEEK MAKER: SYLVIA BELL

YOU WILL NEED

Brown craft paper	Rubber gloves
Roll of 5 cm (2 in) wide gummed paper tape	Building sand and cement
Wooden board measuring 80 x 60 cm (31 x 24 in), waxed (see pages 15-16)	MDF measuring 53 x 36 cm (21 x 14 in)
Tracing paper	Two-part fast setting epoxy resin
Pencil	Piece of card measuring about 15 x 10 cm (6 x 4 in)
Template (page 77)	
Carbon paper	Lollipop stick or modelling tool
Wallpaper paste or water-soluble gum	Grey grout
Bowl	Trowel
Vitreous glass tiles as shown opposite	Builder's float (see page 8)
Mosaic nippers	Squeegee
Safety spectacles	Cloths and sponges
No. 8 paintbrush	Bowl of water
Craft knife	Liquid floor cleaner
Cement	

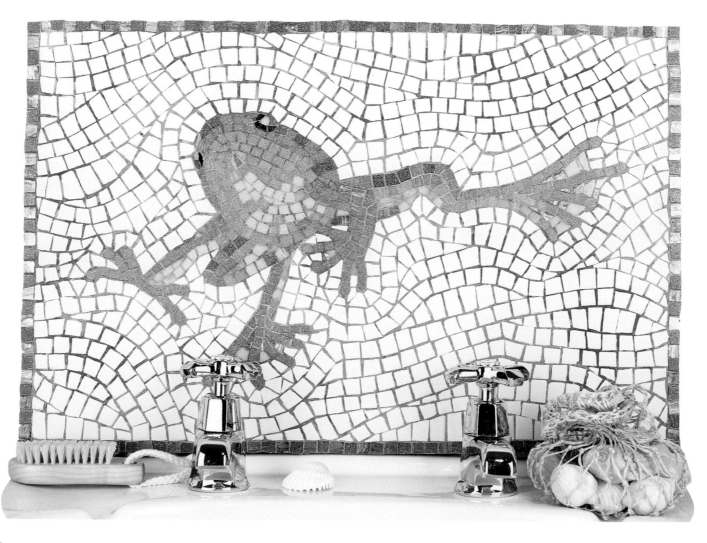

1 copper (30 tiles)
2 black (3 tiles)
3 pale pink (8 tiles)
4 green (30 tiles)
5 emerald green vein (4 tiles)
6 dark green (30 tiles)
7 sage green (63 tiles)
8 pale green (13 tiles)
9 white ceramic (320 tiles)
10 white (2 tiles)
11 marbled white (7 tiles)
12 brown (2 tiles)

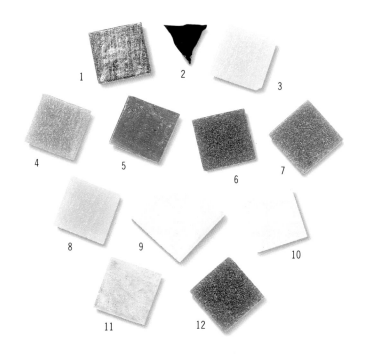

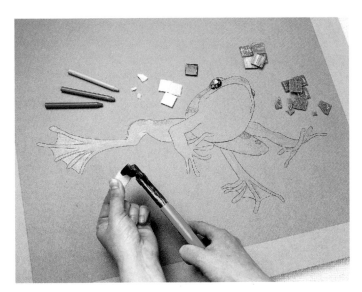

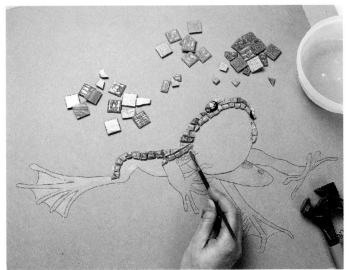

1 Stretch some brown craft paper onto the waxed MDF board (see page 16). Leave to dry for 3-4 hours, depending on room temperature. Then transfer the frog design onto the paper as described on page 74. Remember that the design will eventually be reversed, so you need to trace down the image the 'wrong' way round. Colour in the frog so that you are happy with the tonal values within his body. Try to create a good clear contrast between his dark back and his soft underbelly. Begin to prepare the tesserae.

2 Mix up the wallpaper paste or use any water-soluble paper gum. As the pasting down is only a temporary measure, only use a small amount of paste. The paper will eventually be soaked off by dissolving the glue. In this sort of mosaic it actually helps if you allow a small gap of, say, 1 mm (1/16 in) between each tessera. When grouted, these gaps will delineate the tesserae and emphasize the flow of the design. Begin by mosaicing the frog's eyes (see page 13). Then, working outwards, put in the key line along the frog's back. Try to get this line neat because it is the outside edge and it will give the frog its shape.

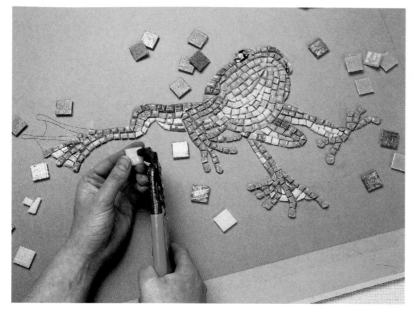

3 When you have finished the frog's dark green head, mosaic the line that describes his underbelly. Try to describe the roundness of the belly by working in neat, curved rows. Continue to mosaic the frog until he is completed.

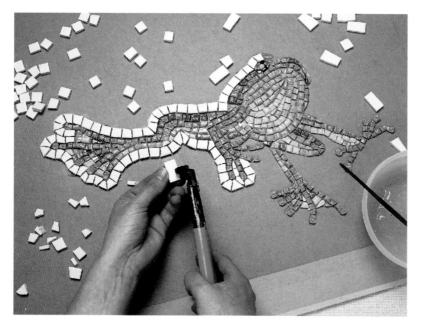

4 Place down the *opus vermiculatum*: the line of tesserae that surrounds the frog. It delineates the subject and is very important as it prevents the background tesserae from 'crashing' into the subject, in this case, our frog. Now mosaic the border using dark green and copper tiles.

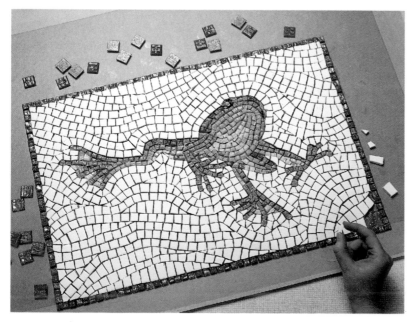

5 Finish off the splashback by mosaicing the surrounding white background area. Echo the 'line of action' of the frog's movement. This is called *opus musivum* and is one of the most dramatic and striking of all the forms of *opus* (see page 17). Leave to dry for three hours or so, depending on room temperature.

6 Take the 53 x 36 cm (21 x 14 in) piece of MDF and 'seal' it with a coat of PVA diluted 50:50 with water. Leave to dry for an hour or so, depending on room temperature. Then cut the mosaic from the waxed board using a scalpel; it will slide off easily if you have waxed the board properly. Keep the board, it can be reused.

Mix the cement with the trowel so that it is the consistency of thick cream. The cement should not be too thick as it needs to fill the gaps between the tesserae. With the grout spreader, carefully butter the surface of the mosaic, trying not to disturb any of the tesserae. Position the buttered mosaic, cement side down, onto the sealed MDF and leave to dry for 24 hours.

7 The next day soak the paper off the mosaic using warm water. Wipe the water onto the paper and give it a few minutes to soak in. The paper should peel away quite easily, but do this slowly. If any tesserae are loose and come away, put them to one side and glue them back into place using the fast setting two-part epoxy resin mixed in a well ventilated room. Finally, grout and clean the mosaic in the normal way (see pages 16-17).

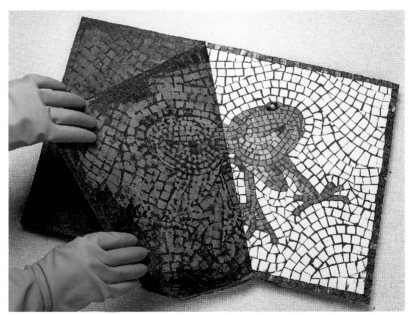

TO FIX A MOSAIC ONTO A WALL

First prepare the surface of the wall where the mosaic is to be fixed. Clean it so that it is free of dirt and grease and then seal it with a coat of PVA diluted 50:50 with water. Leave to dry for 1-2 hours, depending on room temperature.

Then render the area of the wall where you want the mosaic to be with a coat of cement. Use the trowel to smooth the rendering, getting it as flat as possible – the mosaic is only a skin and will only be as flat as the wall. When satisfied, key the surface and leave to harden for 3-4 hours.

'Butter' the ribbed side of the mosaic with cement. The cement should not be too dry as it needs to fill the gaps between the tesserae. Apply the mosaic to the rendered wall. Use a builder's float (see page 8) to push the mosaic and flatten it against the wall.

Leave the mosaic to harden for a few days and then soak off the paper and grout the mosaic in the normal way. Two days later, polish off any scum on the surface using floor cleaner and a damp cloth.

FISH DISH

The durability of mosaics means that they are suitable for kitchens and bathrooms and, because of this, fish are an ever popular choice of subject.

I bought this plastic, fish-shaped platter many years ago, attracted to the way it looked in a shop window. These days, many department stores sell similar ones as picnicware. When I decided to mosaic the dish, I chose a warm, fiery red fish: the lyre-tailed sea bass. The white underbelly is in stark contrast to the deep red back of the fish. It is important to harmonize the top and bottom by gradually blending in yellows through to oranges and finally to the reds.

The eye was made to stand out from the strong red behind it by separating it with a dark ring of brown followed by a light ring of white. If you don't like this effect, then an alternative idea would be to make the colour of the fish's body a softer colour so that there is a good tonal contrast and the features stand out better. We cut long, thin tesserae to achieve the delicacy necessary for the fins.

SIZE OF PLATE: 40 x 30 CM (16 x 12 INCHES)
DESIGNER: MARTIN CHEEK
MAKERS: MARTIN CHEEK AND ALAN WELCOME

YOU WILL NEED

Vitreous glass tiles as shown opposite	Trowel
Plastic fish-shaped picnic plate	Plastic grout spreader
Mosaic nippers	Rubber gloves
125 ml (4 fl oz) wood adhesive in a dispenser	Craft knife
	Cleaning cloth
Cocktail stick	Liquid floor cleaner
Safety spectacles	Abrasive cleaning pad
Face mask	Large 'D' ring with screw
Rubber gloves	Two-part, fast-setting epoxy resin
450 g (1 lb) of powdered grout	Piece of card measuring 15 x 10 cm (6 x 4 in)
Bowl of water	
Mixing board for the grout	

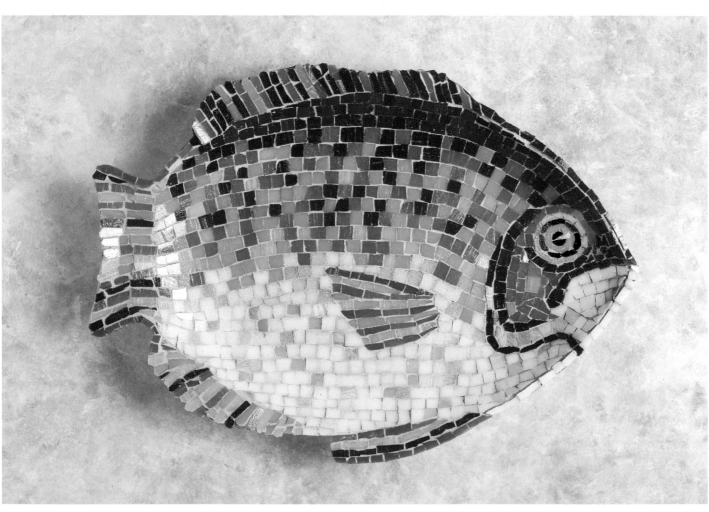

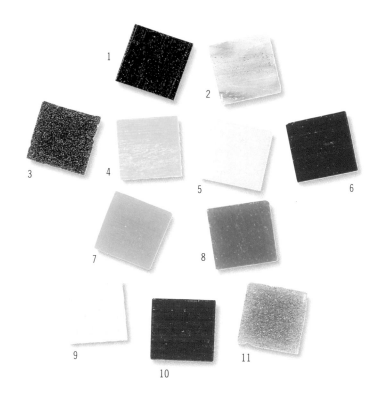

1	black (3 tiles)
2	marbled pink (4 tiles)
3	brown (2 tiles)
4	yellow (26 tiles)
5	soft pink (75 tiles)
6	scarlet (32 tiles)
7	tangerine (32 tiles)
8	orange (60 tiles)
9	white (3 tiles)
10	bright red (44 tiles)
11	mauve (8 tiles)

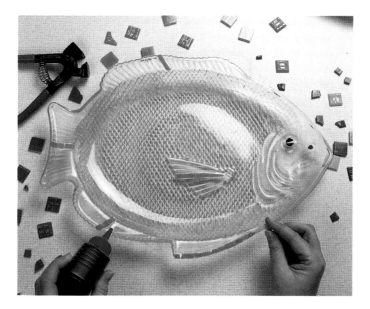

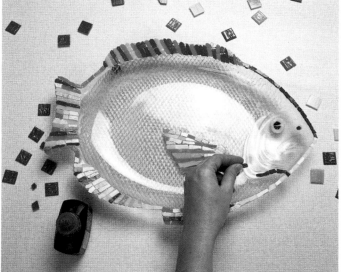

1 I started this project by mosaicing the fins of the fish. Because the tesserae here are thinner, these areas will take longer to mosaic. I like to start on the slowest part of the mosaic and get that bit done, so that I can finish on a 'home straight'. By cutting the tiles into long thin strips (see page 12) you can emphasize the delicacy of the veil-like fins compared to the more solidly mosaiced body of the fish.

Because the plastic surface is slippery, initially lay a few key lines and allow them to set. For the same reason, place the centre of the eye in position, nibble a circle (see page 13), cut it in half and wedge a thin white triangular highlight between the two halves. You may find it helps to use a cocktail stick to finely position the pieces. Nibble a tiny circle for the fish's nostril and glue it in position.

2 Once fast, the key lines will act as buffers against which you can place the adjoining rows of tesserae. Fanning outwards from the centre, mosaic the top dorsal fin in the various reds, orange, tangerine and yellow. Repeat for the other fins. Mosaic the key line that forms the jowl of the fish.

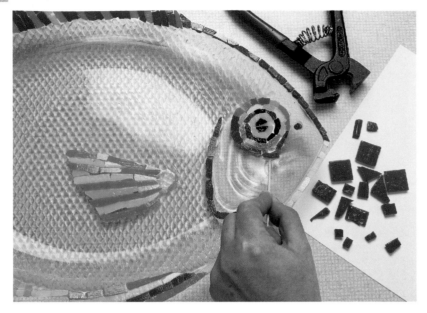

3 To run the yellow ring around the eye, cut a large circle out of one tile (see page 13), cut it into quarters and then nibble the centre out of each quarter. Arrange these tesserae around the black centre to re-form the circle. Keep working outwards adding a brown, then white and finally a red and orange ring to the fish eye. The brown ring will delineate the yellow one, the white ring will make the whole eye stand out from the red body, and the red and orange ring will act as an *opus vermiculatum* (see page 17) stopping the tesserae of the body from 'crashing' into the white ring.

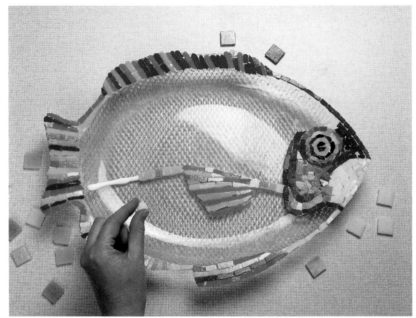

4 Continue to mosaic the head of the fish. Try to get a good, strong, clear line between the line of the red upper lip and the line of the white lower lip which form the mouth. This will help give the fish its particular expression. Run the white key line along the middle of the fish's body and allow to dry.

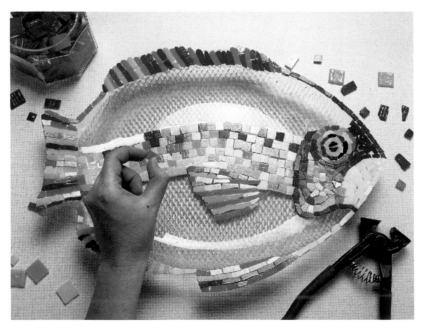

5 Fanning outwards from the centre, mosaic the fish's upper body. As you work upwards with each row, use a little less yellow, replacing it with tangerine, then a little less tangerine, replacing it with orange, and so on, slowly blending in each colour as you go. By the last row you should be using predominantly scarlet with the occasional piece of bright red.

6 Mosaic the lower part of the fish's body using a predominance of soft pink tiles. Pepper the pink with the occasional yellow and mauve tessera. The final few rows where the plate slopes up are particularly tricky to mosaic. The remaining gaps always appear to want larger tesserae than they actually need. Be patient and, if necessary, spend time nibbling each tessera to fit.

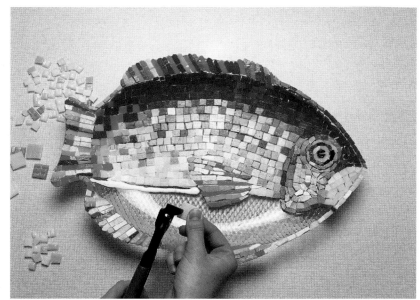

7 Continue in this way until you have finished the fish's entire body. Leave to dry until the PVA goes clear, taking up to four hours. (This is longer than usual because whereas MDF is absorbent which helps the drying process, this plastic plate isn't.)

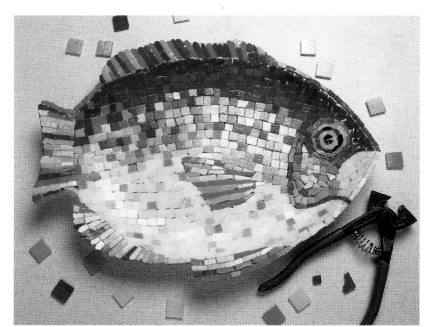

8 When the glue has set, grout and clean the mosaic in the normal way, as described on pages 16-17. Although the squeegee is useful for applying the grout to the flatter areas of the plate, you will find that you have to use your fingers (wearing rubber gloves) to grout the curved edges. When you have finished cleaning and wiping off the excess grout, prod with your craft knife to check there are no tesserae hidden beneath the bed of grout (pay particular attention to the curved sloping sides during this operation). Then allow to dry for at least two days before cleaning off the surface scum as usual.

When it is cleaned and dry, you can, if you wish, hang your plate on an interior wall. Glue a large 'D' ring to the back of the plate using fast-setting two-part epoxy resin in a well ventilated room. Scratch the surface with your craft knife first so that the glue will key to the plastic surface.

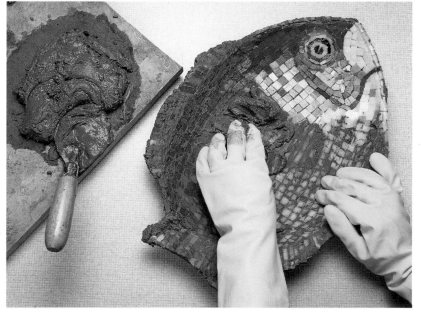

SCALLOPED TERRACOTTA WALL POT

Once again, the actual shape and design of the pot itself suggested this mosaic. If the pot is a scalloped shape, why not mosaic a scallop shell onto it? The pattern of a scallop shell is an interesting proposition for the mosaic artist. As well as the ribbed lines which run vertically down it, which are wedge shaped, getting wider as they fan out, there are also curved bands of colours that run horizontally across it. So you need to think about the changes in colour running across the shell as you mosaic it vertically.

Incidentally, mosaic is an ideal way to re-cycle broken pots. Once glued back together again, the mosaic skin hides any sign of damage to the outer surface, while the inside of the pot can be filled with your favourite plant. Because we used waterproof tile adhesive this pot is suitable for outside use.

It is not necessary to grout the finished mosaic when you use this method because the smalti 'self grouts' – as you push each tessera into the adhesive, adhesive is forced up between the gaps. That said, it is important to try and place the tesserae tightly together so that the tile adhesive does not intrude onto the final surface.

OVERALL DIMENSIONS: BACK SEMI-CIRCLE:
38 X 17 CM (15 X 7 IN)
DISTANCE FROM FRONT TO THE BACK OF THE
POT: 18 CM (7¼ IN)
DESIGNERS: MARTIN CHEEK AND
PAUL HAZELTON
MAKER: PAUL HAZELTON

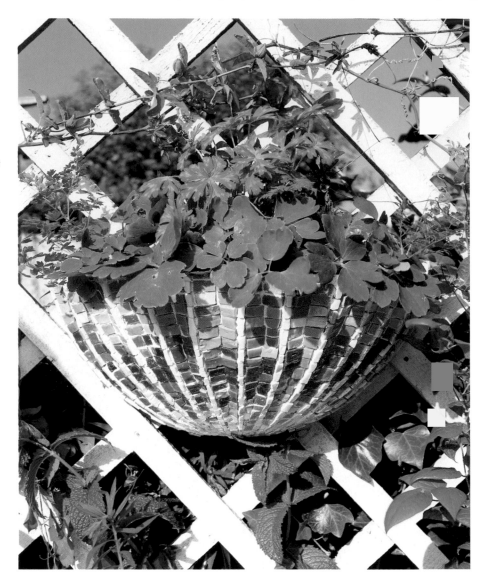

YOU WILL NEED

Scalloped wall hanging terracotta pot
Coloured pastels or chalks
Scallop colours from a 20 kg (40 lb) box of irregular mixed smalti as shown right
Paper bowls or plates
1 kg (2 lb) waterproof tile adhesive
Plastic bowl
Trowel
Mosaic nippers
Safety spectacles
Rubber gloves

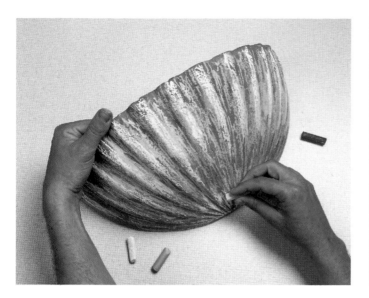

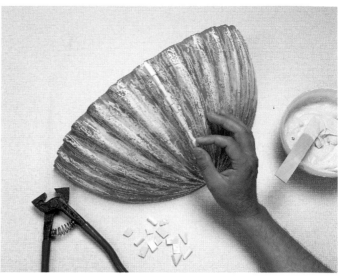

1 Colour the surface using pastels or chalks to give yourself an idea of how you want the finished pot to look. If you study a real scallop shell you will notice that the bands of colour go in both directions – both along and across the grooves – so try to capture this effect.

2 Sort out the smalti into small bowls containing the colours that you intend to use, eg one bowl to contain various shades of pinks, another oranges, and another whites. Mix up the waterproof tile adhesive with water to the consistency of smooth porridge and run a thin line of the adhesive along one of the ribbed lines. Mosaic smalti down this line and accentuate the rippled surface by placing this central line 'end on' to the pot.

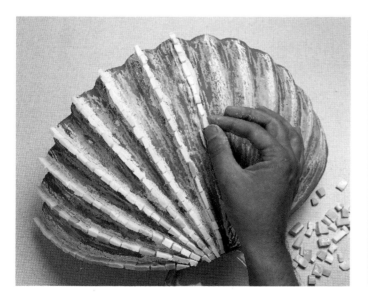

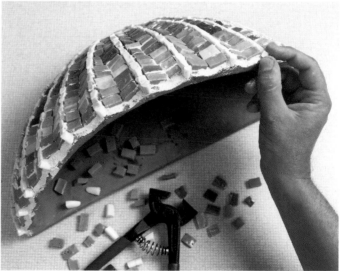

3 Continue to mosaic the rest of the peaked ribbed lines. Try to match the colours of your chalks, but keep these lines soft and pastel in tone. It may help to lean the pot against a cardboard box to prop it up so that you can work around the scalloped surface.

4 Mosaic the troughs between the peaks. Once again, try to emulate your initial colour scheme and make these areas darker in tone. Lay the smalti flat side down to accentuate the rippled surface of the scallop shell. From the box of irregular mix, pick out some rounded 'end' tesserae. Place one of these rounded tesserae at the end of each peaked ribbed line to finish it off. Finally, mosaic the top line between the rounded tesserae to complete the scallop pot. Leave to dry for three hours and then fill the pot with an appropriate plant and hang in a sunny spot on your garden wall.

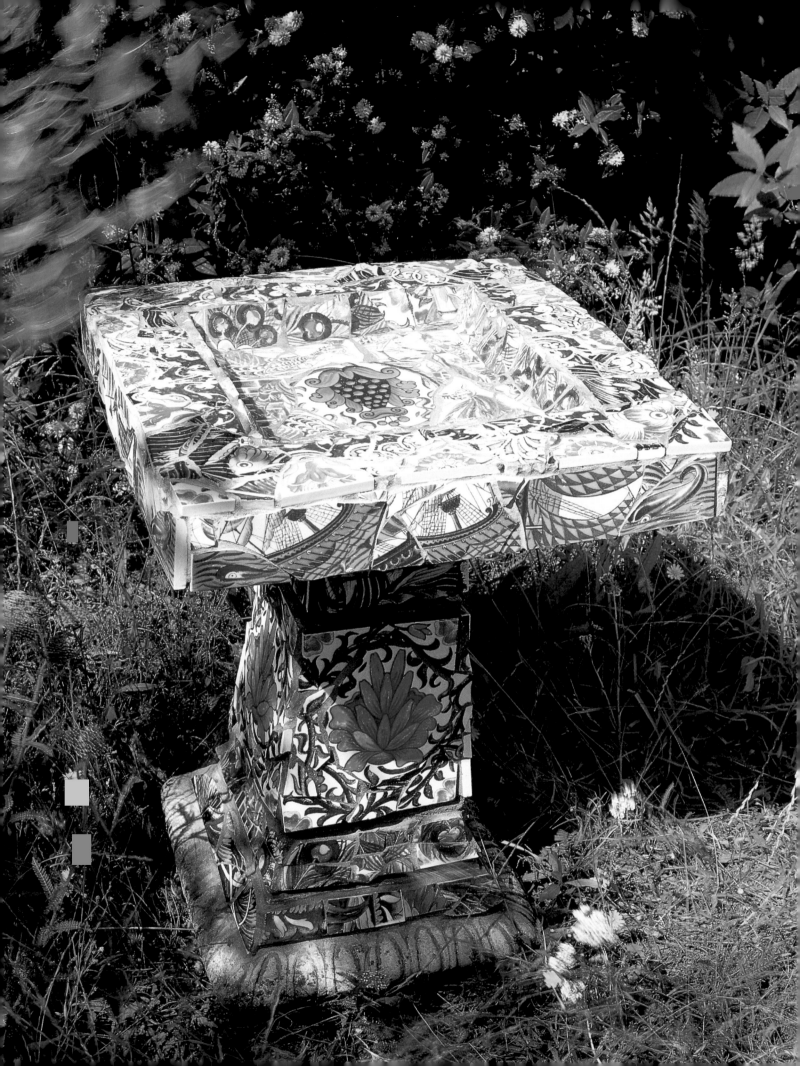

BIRD BATH

One of my favourite designers is the Victorian, William de Morgan. Reproductions of his tiles are still manufactured and are widely available. The cost of these exquisite pieces would normally be beyond the pocket of the average mosaic artist, but I was lucky enough to get hold of some seconds.

In designing this project, I wanted it to be obvious that I had used the William de Morgan tiles, so I tried to keep the overall feel of the piece in keeping with the designs on the tiles, grouping the different motifs – the peacocks, ships and fish – together in their own area.

This method is quick by comparison to ordinary mosaic. The individual pieces can be quite big and large areas can be covered in a relatively short time. This project was completed by Sylvia and me in just one day. Using broken tiles or china is an excellent way of recycling an attractive material that would otherwise be thrown away. There are 'ceramic dumps' where you can pillage such trophies. There is no specific list of tile requirements here since, for obvious reasons, it will not be possible to reproduce this design exactly.

Overall dimensions: Bird bath: 42 x 42 x 5 cm (16 x 16 x 2 in)
Plinth: Mosaic area consists of four trapeziums:
13 x 27 x 47 cm (5 x 10½ x 18 in) high
Designer: Martin Cheek
Makers: Martin Cheek and Sylvia Bell

YOU WILL NEED	
Assortment of tiles as shown below	Bowl
Mosaic nippers	Bowl of water
Rubber gloves	Mixing board for the grout
Safety spectacles	Trowel
5 kg (11 lb) rapid-set floor and wall tile adhesive	Plastic grout spreader
	Cleaning cloth
Lollipop stick or metal modelling tool	Liquid floor cleaner
1 kg (2 lb) of powdered Wide Gap grout	Abrasive cleaning pad

1 Using the tile nippers, break up some of the tiles and arrange them in an interesting way on the top surface of the bird bath. (You may want to wear rubber gloves to do this as the tiles can be sharp.) Use some of the most attractive tiles for this surface as this is the one that is seen the most. You will get a neater finish if you use the straight glazed machine edge of the tile for the edges of the birdbath. When you are happy, transfer these tiles to a board and put them aside.

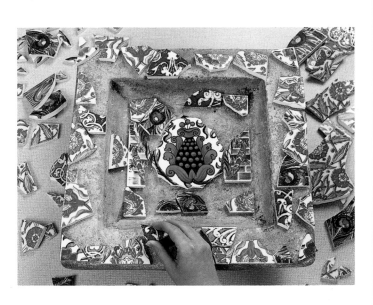

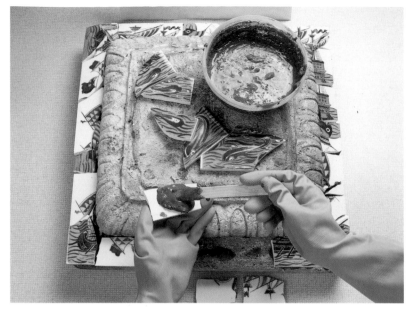

2 The William de Morgan tiles are very thick (6 mm [¼ in]) and as you mosaic each surface you leave the thickness of the tile showing on the adjacent surface. In order to disguise this as much as possible, it is important to start on the underside, then the sides, and finally the top surface of the bird bath, mosaicing over the edge of the tiles in each successive case. So, beginning on the bottom of the bird bath, cut the tiles to size and butter each piece with the rapid set floor and wall tile adhesive before finally placing it down. Leave to dry.

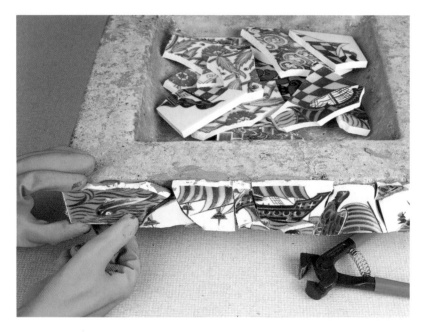

3 Now mosaic the four sides, making sure that you cover over the edges of the tiles on the underside. The William de Morgan ship designs had dolphins swimming along the bottom edge. If you are extremely skilful (or lucky!) you will be able to cut these out and place them on the corners of the bird bath.

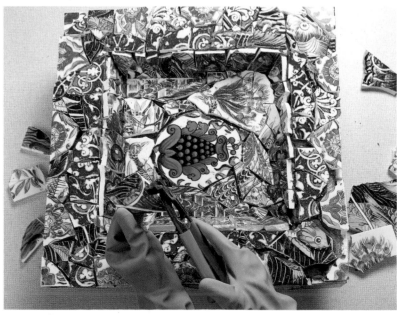

4 Bring back the board with the pre-sorted tiles on and stick these down. Once again, cover the edges of the tiles on the sides. You will be aware that the gaps between the tesserae are much bigger than in any other type of mosaic, this is the nature of working with broken tiles and/or china. Continue until you have covered the entire top surface. We tried to keep the colours together for certain areas, such as reddish tiles with peacock feathers for the inner edge contrasting with darker blue tiles on the uppermost inner edge.

5 Grout the completed bird bath as described on pages 16-17. Because the gaps are large, use a wide gap grout. You may find it easier to squidge the grout in with your fingers than use the grout spreader. Be generous with the grout, filling in any crevices, as this will strengthen the final piece. Wipe off the excess grout. The next day, use a piece of broken tile as a scraper to remove any excess grout that is obscuring any glazed area of tile. This is easier and quicker than it sounds.

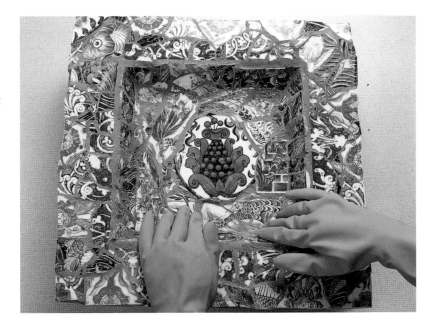

6 Now start on the plinth. Our plinth had attractive fluting on it which I didn't want to lose. There were also ribbed bands with tight curves that would have proved difficult to mosaic. I decided to leave these areas unmosaiced and blend the grout into the curves to incorporate it into the overall design. If your bird bath is basically square and plain, it may well be better to mosaic over the entire surface.

Once again, I chose a large blue flower as the centrepiece for each side and the poppies for the corners of the central panel. Try to create contrasts between the neighbouring areas.

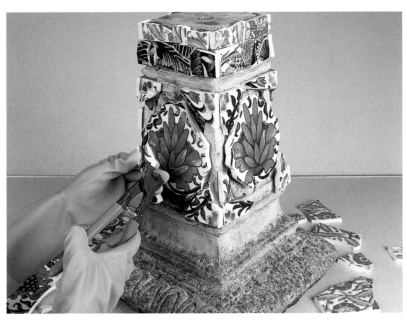

7 Continue in this way until you have covered all of the mosaic areas. Grout and clean up the plinth in the same way as the bird bath. Rub some grout into the untiled areas to blend them in with the tiled areas. In this case, the grouting process goes a long way towards achieving a harmonious whole to the finished piece. Allow to dry for at least two days before cleaning off the surface scum with the liquid floor cleaner and abrasive pad.

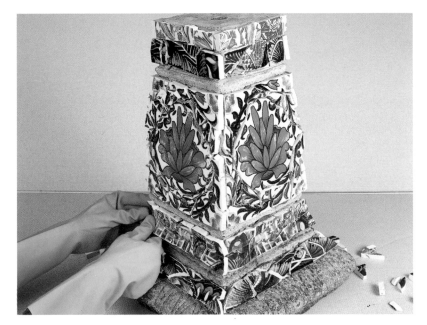

TEMPLATES

SIZING THE DESIGN

The easiest way to enlarge any of the designs featured on these pages is to use a photocopier with an enlarging facility. If you don't have access to such a machine, use the square method. Draw a grid of small squares over the outline and then draw a grid with much larger squares on a blank piece of paper. You will then be able to transfer the design, square by square.

TRANSFERRING THE DESIGN

To transfer the design onto your mosaicing surface, whether it be MDF, skim ply, acetate, or any other material, place a sheet of carbon paper, ink side down, on the board or mosaic surface (if the area is a large one, you will need to use more than one sheet of carbon). Tape or pin down your sized template and trace off the design onto tracing paper and place it on top of the carbon paper. Firmly trace over the design with a sharp pencil to transfer it onto the mosaicing surface.

Trivet (see page 26)

Cock Clock (see page 42)

Fingerplates (see page 30)

Wave Picture Frame (see page 44)

Roman
Paving Slab

(see page 52)

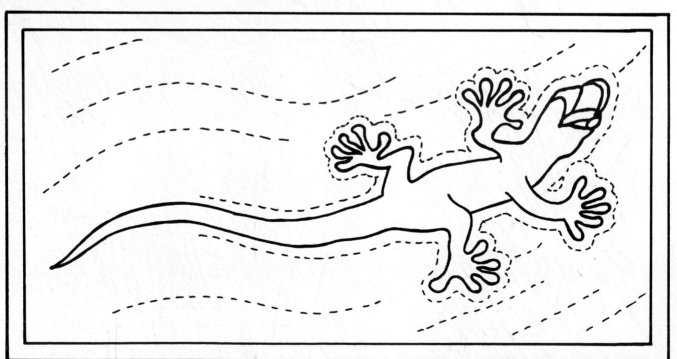

Gecko Plaque (see page 38)

Pebble Mosaic
Paving Slab
(see page 48)

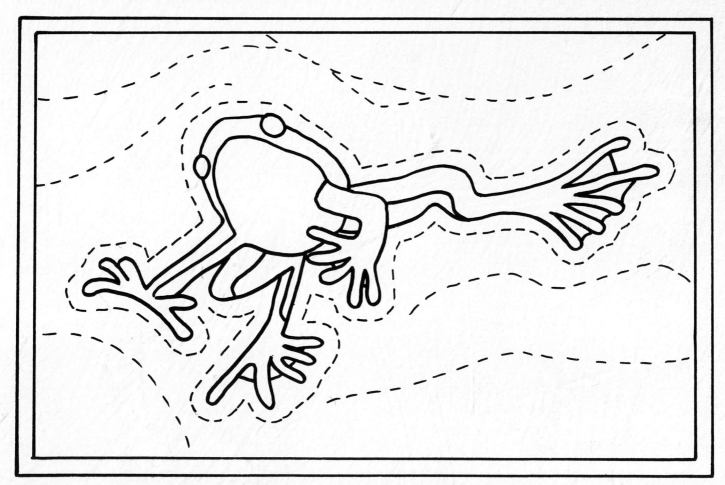

Frog Splashback (see page 60)

ACKNOWLEDGMENTS

By now you will have realized how much patience is required to make successful mosaics. This book is the result of a dedicated team. I would like to take the opportunity to thank all of my friends and colleagues who have been so supportive, particularly:

THE MOSAIC TEAM:

Yvonne McFarlane, who commissioned this book and has helped and encouraged me every step of the way with great humour.

Shona Wood, who did more than take the photographs so cheerfully and patiently. Shona's artistic eye was always appreciated.

My assistant, Sylvia Bell, for her tireless help, for which I am so grateful.

My dear friend Alan Welcome, for producing and marketing the mosaic kits so brilliantly as well as helping on this book.

Rebecca Driscoll, Paul Hazelton, Liz Sims, Marilyn Wharton and Kim Williams, who each made mosaics for some of the projects and for the Gallery. In every case, their inputs were inspired and invaluable.

Lady Davis, for allowing us to photograph her mosaics.

Carol Stephenson, without whom our whole house (and me) would be in greater chaos than it already is.

Joe Briggs, for dropping in on us whenever he felt like it.

Rodney and Dinah Aird-Mash, for allowing us to photograph some of the finished mosaics in their beautiful garden in Broadstairs, Kent.

My Mom and Dad, who never stopped believing in me and helped me whenever I needed it.

My son and heir Thomas, for allowing me to steal some of his best ideas, long may his imagination continue to grow.

My baby daughter Mollie, who entertains us all and lifts all our spirits.

And finally, to my dear wife Margaret, for putting up with me and my mess for all these years.

THANKS ALSO TO:

Evode Ltd, for supplying Evo-Stik Resin W PVA adhesive and Araldite two-part epoxy resins; Scumble Goosie for lending the blanks for the fish table (page 64), bead box (page 36), button box (page 22) and the cat firescreen (page 23); The Button Queen, London and The Bead Shop, Portobello Road, London and Jane Churchill, Ideal Standard for the loan of the taps which are photographed with the Frog Splashback on page 60 (see Suppliers for addresses). Thanks also to Gideon and Jessica of the Upstart Gallery in Bevington Road, London W10 who have exhibitions of work by the best contemporary mosaic artists.

MOSAIC KIT AND MOSAIC COURSES
INFORMATION

Some of the projects in this book are available as kits. To order the kits featured in this book, or to obtain a list of kits, please send an sae to: Martin Cheek Mosaic Kits, 93 Stone Road, Broadstairs, Kent, CT10 1EB, England.

Martin Cheek runs three-day weekend mosaic courses. For information about the courses and a list of dates, please send an sae to: Flint House, 21 Harbour Street, Broadstairs, Kent, CT10 1ET, England.

SPECIALIST SUPPLIERS

Local DIY and hardware stores stock many useful tools, adhesives and other materials. Materials and equipment in this book may be obtained from the following suppliers, many of which will send orders by mail.

UNITED KINGDOM

Caesar Ceramics
358 Edgeware Road
London W2 1EB
Tel: 0171 224 9671
Fax: 0171 224 9854
also
6 The Broadway
Chalfont St. Peter
Bucks SL9 9DX
Tel: 01753 881688
Fax: 01753 882760

Edgar Udny & Co Ltd
The Mosaic Centre
314 Balham High Road
London SW17 7AA
Tel: 0181 767 8181
Extensive stock of ceramic tiles, vitreous glass, smalti and gold smalti plus mosaic tools. Importers and distributors of mosaics and tiles. Catalogue available.

Evode Ltd
Common Road
Stafford
ST16 3EH
*For technical advice
Tel: 01785 57755.
Suppliers of Evo-Stik 'Resin W' PVA adhesive and Araldite two-part epoxy resins.*

Mosaic Workshop
Unit B
443-449 Holloway Road
London N7 6LJ
Tel/Fax: 0171 263 2997
Suppliers of marble tesserae cut to order.

Reed Harris Ltd
Riverside House
Carnwath Road
London SW6 3HS
Tel: 0171 736 7511
Fax: 0171 736 2988
Ceramic and marble tiles plus unglazed Cinca ceramic tiles from Portugal. Catalogue available.

Scumble Goosie
Lewiston Mill
Brimscombe
Stroud
Gloustershire
Mail order. Suppliers of furniture and accessories suitable for mosaicing or painting.

Specialist Crafts Ltd
PO Box 247
Leicester LE1 9QS
Tel: 0116 251 0405
Fax: 0116251 5015
Mail order. Large variety of craft materials including smalti, vitmos, tile cement, nippers and other equipment.

Robert Still
Garden Flat
37 Savernake Road
Hampstead
London NW3 2JU
Mosaic fixer:
Tel: 0171 284 4475
Mobile: 0956 528201

Tim Stone
PO Box 198
Chesterfield S40 1FQ
Tel: 01246 206122
Supplier and fixer of marble; will cut to order and provide marble tesserae on request.

GENERAL SUPPLIERS

UNITED KINGDOM

Beads
259 Portobello Road
London W11 1LR
Tel/Fax: 0171 792 3436
*Personal callers only.
Broken beads for mosaic.
Suppliers of the beads used
in the Bead Box on pages
36-7.*

Button Queen
19 Marylebone Lane
London W1M 5FE
Tel: 0171 935 1505
*Suppliers of the buttons
used in the Button Box on
page 22.*

Jane Churchill
Fabrics and Wallpapers
19/23 Grosvenor Hill
London W1X 9HG
Tel: 0171 493 2231
*Suppliers of Indian
Summer fabric photo-
graphed with the Indian
Elephant on page 24.*

Creative Beadcraft Ltd
Denmark Works
Beaumond End
Amersham, Bucks
HP7 0RX
Tel: 01494 715606
Mail order beads.

James Hetley & Co. Ltd
Glasshouse Fields
London E1 9JA
Tel: 0171 790 2333
*Mail order suppliers of
coloured glass*

Ideal Standard
The Bathroom Works
National Avenue
Kingston Upon Thames
Hull HU5 4HS
Tel: 01482 346461

Langley London Ltd
The Tile Centre
161-167 Borough High
 Street
London SE1 1HU
Tel: 0171 407 4444
*Suppliers of vitreous glass
and ceramic tiles*

Tower Ceramics
91 Parkway
Camden Town
London NW1 9PP
Tel: 0171 485 7192

ITALY

Lucio Orsoni
Cannaregio 1045
30121 Venezia
Italy
Tel: (0)41 717255;
Fax: (0)41 5240736
*Major stockists of smalti
and gold smalti.*

SOUTH AFRICA

Art, Craft & Hobbies
72 Hibernia Street
George
6530
Tel. (0441) 74 1337
*Mail order service
available nationwide*

Crafty Suppliers
32 Main Road
Claremont
Tel. (021) 61-0286
Fax. (021) 61-0308

Southern Arts and Crafts
105 Main Street
Rosettenville
Tel. and fax
 (011) 683-6566

AUSTRALIA

BBC Hardware
Head Office
Building A, Cnr
Cambridge & Chester
 Streets
Epping NSW 2121
Tel: 02 876 0888
*Branches throughout
Australia*

Camden Art Centre Pty
 Ltd
1880200 Gertrude Street
Fitzroy
Victoria
Australia 3065

Ceramic and Craft
 Centre
52 Wecker Road
Mansfield 3722
Queensland
Tel: 07 3343 7377
*Branches throughout
Australia*

Ceramic Hobbies Pty
 Ltd
12 Hanrahan Street
Thomastown 3074
Victoria
Tel: 03 466 2522

Ceramicraft
33 Deeinup Way
Malaga 6062
Western Australia
Tel: 09 249 9266

True Value Hardware
15 branches, contact
1367 Main North Road
Para West Hills SA 5096
Tel: 281 2244

NEW ZEALAND

Handcraft Supplies Ltd
13-19 Rosebank Road
Avondale
Tel: 09 8289834

NZ Hobby Clay & Craft
Co Ltd
1/80 James Fletcher
Drive
Mangere
Tel: 09 270 0140

The Tile Company
782 Great South Road
Penrose
Tel: 09 525 5793

Trendy Tims Ltd
16-18 George Tce
Onehunga
Tel: 09 6344531

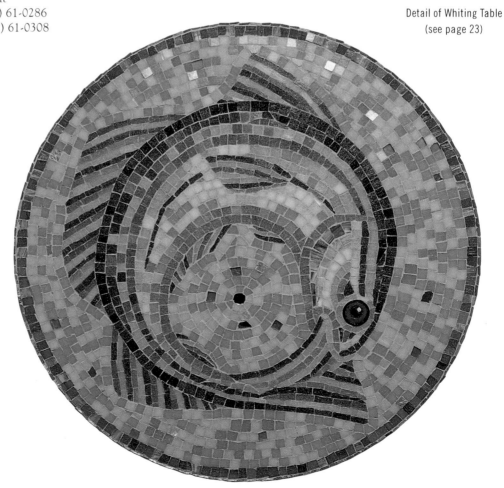

Detail of Whiting Table
(see page 23)

INDEX

Entries in **bold** represent projects
Page numbers in *italics* represent photographs